POSTCARD HISTORY SERIES

Columbia University and Morningside Heights

F. Earl Christy, the foremost artist of American "college girl" postcards occasionally portrayed college boys. This Columbia football player in blue and white regalia was part of a series of *College Kings and Queens of the Ivy League* published around 1905 by Raphael Tuck and Sons, art publishers to their majesties the king and queen of England.

On the front cover: By 1910, students could travel by carriage, automobile, trolley, and subway to Columbia University's Morningside Heights campus. This view along the Boulevard (now Broadway) toward West 116th Street shows the buildings on the Upper Quadrangle along with remnants of the Bloomingdale Asylum. Flanking the centerpiece of Low Memorial Library to the left are South Hall, the School of Mines (now Lewisohn), and the School of Engineering (now Mathematics); and to the right, St. Paul's Chapel, Macy Villa (now Buell Hall), and Kent Hall under construction. (Author's collection.)

On the back cover: This spectacular view of Morningside Heights from Manhattan Avenue at West 114th Street in Harlem shows the rugged cliffs of Morningside Park around 1915 and two of the pioneering institutions on the heights, the Cathedral Church of St. John the Divine and St. Luke's Hospital. The statue in the foreground of Lafayette and Washington was sculpted in 1900 by Frederic-Auguste Bartholdi. (Author's collection.)

POSTCARD HISTORY SERIES

Columbia University and Morningside Heights

Michael V. Susi

ARCADIA
PUBLISHING

Published by Arcadia Publishing
Charleston SC, Chicago IL, Portsmouth NH, San Francisco CA

Printed in the United States of America

Library of Congress Catalog Card Number: 2006937593

For all general information contact Arcadia Publishing at:
Telephone 843-853-2070
Fax 843-853-0044
E-mail sales@arcadiapublishing.com
For customer service and orders:
Toll-Free 1-888-313-2665

Visit us on the Internet at www.arcadiapublishing.com

Columbia University

Dedication of the New Site, Morningside Heights

Saturday the second of May 1896

at three o'clock

*This card should be presented not later than half past two p.m.
at the entrance on the Boulevard near 118th Street*

West Hall

The dedication ceremony for Columbia University's new site on Morningside Heights took place on May 2, 1896, eight months into construction of its first building: Low Memorial Library. Classes would not begin there for another 17 months.

CONTENTS

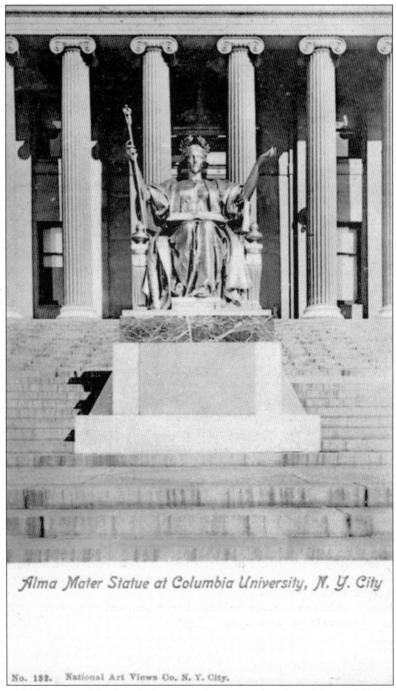

Alma Mater Statue at Columbia University, N. Y. City

As one ascends the steps of the South Court on the approach to Low Memorial Library, Daniel Chester French's *Alma Mater* appears. She is seated on a throne welcoming all to this magnificent and unique urban campus. A gift of Mrs. Robert Goelet and her son, Robert Goelet Jr., in memory of Robert Goelet Sr., class of 1860, she was presented to the university in 1903. Originally covered in pure gold leaf, she is more familiar to recent generations of Columbians in her now muted tones of green and brown. Her vision, intelligence, and fortitude, however, are unwavering.

ACKNOWLEDGMENTS

Working on this book would not have been possible if not for the support of my partner, Sean Sawyer, who kept me focused on writing the numerous captions accompanying the images and then edited them down substantially so that more of the postcard image could be presented. My good friend, Joseph Ditta of the New-York Historical Society, helped immeasurably with his encouragement and tireless research skills.

All of the postcards, maps, and photographs in this book are from my collection except for 17 exceptional postcards provided by postcard collector and dealer Bob Stonehill. This is my second project where I have asked him to provide some of his images, and I am astounded by his generosity almost as much as I am by his collection. I have also included one spectacular double-length postcard used with the permission of the University Archives at Columbia. I wish to say thank you particularly to Jocelyn Wilkes and Jennifer Ulrich in the University Archives for their many years of professional and friendly assistance to me in my various endeavors.

I have been collecting postcards now for almost 20 years, and there is no better source than the Metropolitan Postcard Club. Established in 1946, it is the oldest continuous postcard club and still holds monthly meetings and twice-yearly bourses with dealers from all over the world. Though I regretfully admit that I do half of my collecting nowadays on eBay, there is nothing like searching through boxes of postcards with other collectors in an attempt to find new and interesting views. I send a big kiss to Joan Kay, the current president of the club, and her partner Ron Kronheim, from whom I bought much of the material in this book.

And finally, I would like to thank my editor at Arcadia, Erin Vosgien, who e-mailed me last summer to ask whether I still wanted to do this book, a book which I had initially proposed, and received approval for, eight years prior. It is through her guidance and perseverance that this volume appears before you now.

This volume is dedicated to Susan Mescher, Lara Khan, and Vicky Prince. Their vision, intelligence, and fortitude are unwavering.

INTRODUCTION

This is our college on Morningside, cresting the schist of Manhattan,
Leafless, a campus of granite, devoid of quaint trellising arches,
Bare of traditional ivy and classical alleys of cedar.
Bounded by Broadway and Amsterdam, cloven in twain by a pavement,
Set in a canyon of sky-scrapers, flecked by the dust of the city.
This is Columbia's campus, surrounded by streets and buses,
Girdled about by no walls but a love that endureth forever.

–Henry Morton Robinson, 1924

Thus begins Henry Morton Robinson's epic poem entitled "Children of Morningside." Written after his graduation from Columbia College in 1923, the poem expresses the pride and, dare I say, love that many generations of students have felt for the school and the university. It is also imbued with a certain feeling of deficiency that Columbia is such a distinctly urban campus. And to think that these sentiments were written at a time when there still existed a rather sizeable green space north of the campus from West 119th to West 120th Streets and only 30 years after Columbia had led the way to urbanizing Morningside Heights.

In 1892, when Columbia bought its first parcel of land in what soon became known as Morningside Heights, the few buildings and chapel of the Bloomingdale Insane Asylum sat on the highest plateau on the heights, 150 feet above the Hudson River in the area from West 116th to West 120th Streets off the Boulevard (now Broadway). There were commanding views to be had in all directions over the hilly, rocky, and lush land. There were no apartment buildings, only wooden farmhouses and shanties, a few row houses, and some large houses lining Riverside Drive. A few blocks to the south stood the Leake and Watts Orphan Asylum, which had just sold its site for the development of the Cathedral Church of St. John the Divine. Across West 113th Street, St. Luke's Hospital was rising. The Ninth Avenue Elevated railway came this far uptown but skirted the heights at Morningside Park (see map on page 10). But merely 30 years later, the neighborhood and campus were much as they appear today, with most of its institutions, residences, and services in place. What happened to Morningside Heights during these three decades?

We have heard much in the past few years about the transformative effect of college upon the young men and women who pass through it. Austin Quigley, current dean of Columbia College, has often related that every graduate he has met tells him of the extraordinary transformative power of Columbia on their lives. But we hear less often about the transformations of Columbia's campus and its neighborhood, a subject increasingly relevant as Columbia begins expanding once again to the north.

There have been some recent scholarly monographs published by Columbia faculty that deal with these issues. Barry Bergdoll's *Mastering McKim's Plan: Columbia's First Century on Morningside Heights* and Andrew Dolkart's *Morningside Heights: A History of Its Architecture and Development* are both highly recommended for those who wish to delve much more deeply into the fascinating history of the architecture and institutions of Morningside Heights. But this slim volume of postcard images is meant to be carried with you as you explore the nooks and crannies of the university and the neighborhood where you study, work, and live, or did these things in the past.

Collected here are 200 images from about 1900 to the 1920s that chronicle the growth of a great university and a solid, middle-class neighborhood, home to some of the most influential institutions in the city of New York. In fact, as Morningside Heights developed, the list of institutions relocating here was so impressive that the area was often referred to as the Acropolis of America, with institutions designed to ennoble the mind, body, and soul. By 1895, the year Columbia laid its first cornerstone, the *New York Times* declared that there were "no more beautiful places anywhere than the Morningside and Washington Hill Tops" in describing the heights of northern Manhattan.

The move to Morningside Heights was Columbia College's second move uptown from its original location near Trinity Church in lower Manhattan where it was founded as Kings College in 1754. The college moved to the "Upper Estate" bounded by Madison and Fourth (now Lexington) Avenues and East 49th to East 50th Streets in 1857. Hemmed in on all sides, the trustees began searching for a new location as early as 1890. Low Memorial Library, the first building constructed on the Morningside campus, was completed in 1897. Also completed that year were Havemeyer, Fayerweather, and Schermerhorn Halls, as well as the School of Engineering (now Mathematics Hall). The campus was dedicated a year earlier on May 2, 1896.

The first day of classes on the Morningside campus was October 4, 1897, the beginning of the college's 144th academic year. The recently reorganized university consisted at that time of Columbia College and six university faculties—Law, Medicine, Applied Science (Mines and Engineering), Political Science, Philosophy, and Pure Science. Barnard College, the women's college formally affiliated with Columbia since 1900, moved to the heights upon completion of its first buildings, the Milbank complex, in 1897 (see chapter 4). To the north, Teachers College became affiliated with the university in 1897, four years after moving into its first building, Main Hall, on West 120th Street (see chapter 7). Nearby Union Theological Seminary began classes on the heights in 1910, the same year as the Institute of Musical Arts (see chapter 7). Seven years earlier, the Jewish Theological Seminary was chartered and began classes. Later institutions included International House, which opened in 1924, and the Riverside Church, which celebrated its first service in 1930.

The postcard views contained in this book attest to the tremendous development that these institutions spurred in the first three decades of the 20th century. They include printed postcards that were mass-produced from photographs, and real-photo postcards that were produced in limited quantities from negatives on photographic paper. Among the most impressive and sought after of the real-photo postcards are those taken by photographer Thaddeus Wilkerson (1872–1943), a prolific chronicler of upper Manhattan whose studio was in Washington Heights. The postcard views are supplemented with maps from various sources, some photographs of the Hudson-Fulton Celebration of 1909, and cameo lithograph portraits from *King's Notable New Yorkers 1896–1899*, a compendium of famous men from all professions.

In this, the 110th year of Columbia University's arrival on Morningside Heights, I encourage you to look back at the growth and development of this unique urban campus and its surrounding neighborhood and reflect upon the significance of the changes wrought by the institutions who now share this densely packed plateau of upper Manhattan.

<div align="right">

Michael V. Susi
CC 1985, GSAS 1987 and 1989

</div>

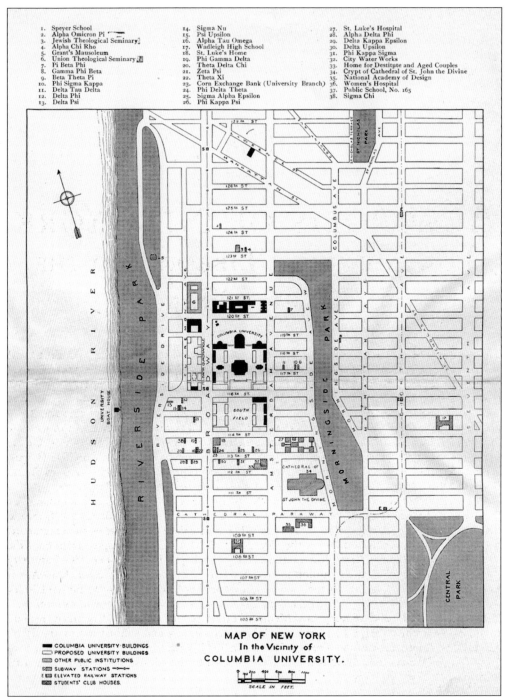

1. Speyer School
2. Alpha Omicron Pi
3. Jewish Theological Seminary
4. Alpha Chi Rho
5. Grant's Mausoleum
6. Union Theological Seminary
7. Pi Beta Phi
8. Gamma Phi Beta
9. Beta Theta Pi
10. Phi Sigma Kappa
11. Delta Tau Delta
12. Delta Phi
13. Delta Psi

14. Sigma Nu
15. Psi Upsilon
16. Alpha Tau Omega
17. Wadleigh High School
18. St. Luke's Home
19. Phi Gamma Delta
20. Theta Delta Chi
21. Zeta Psi
22. Theta Xi
23. Corn Exchange Bank (University Branch)
24. Phi Delta Theta
25. Sigma Alpha Epsilon
26. Phi Kappa Psi

27. St. Luke's Hospital
28. Alpha Delta Phi
29. Delta Kappa Epsilon
30. Delta Upsilon
31. Phi Kappa Sigma
32. City Water Works
33. Home for Destitute and Aged Couples
34. Crypt of Cathedral of St. John the Divine
35. National Academy of Design
36. Women's Hospital
37. Public School, No. 165
38. Sigma Chi

COLUMBIA UNIVERSITY-BUILDINGS
PROPOSED UNIVERSITY BUILDINGS
OTHER PUBLIC INSTITUTIONS
SUBWAY STATIONS
ELEVATED RAILWAY STATIONS
STUDENTS' CLUB HOUSES

MAP OF NEW YORK
In the Vicinity of
COLUMBIA UNIVERSITY.

SCALE IN FEET.

This is a view of Morningside Heights and environs from the *1907–1908 Catalogue and General Announcement of Columbia University* prior to the rerouting of West 125th Street along the path of Manhattan Street in 1920 and the demise of the Ninth Avenue Elevated railway in 1940.

One

ACROPOLIS OF NEW YORK
LOW MEMORIAL LIBRARY AND THE
CAMPUS PLAN

The Trustees of Columbia College purchased the land between the Boulevard (now Broadway) and Amsterdam Avenue from West 116th to West 120th Streets from the New York Hospital in April 1892 for $2 million, prompting the move of the Bloomingdale Asylum to Westchester County. An architectural committee, comprised of the most prominent architects of the day, was established by the trustees. In November 1893, the architectural firm of McKim, Mead and White was chosen to plan the campus not in the Collegiate Gothic style, but in the new monumental Beaux-Arts classicism on display at the 1893 World's Columbian Exposition. Others vying for the opportunity to create the Morningside campus were Charles Coolidge Haight, class of 1861, architect of several buildings on the soon-to-be-abandoned midtown campus, and Richard Morris Hunt, founder and president of the American Institute of Architects.

The McKim, Mead and White master plan of 1894 comprised a composition of four quadrangles on an elevated platform from West 116th to West 119th Streets, with a wooded and leafy area to the north at street level, referred to as the Green. The centerpiece of the plan was a monumental neoclassical library facing south over the city, designed with elements adapted from both the Pantheon and the Roman baths. Just months before work began in September 1895, university president Seth Low pledged $1 million to erect the library in honor of his father, Abiel Abbot Low, a China trader. The cornerstone was laid in December 1895, and Low Memorial Library was completed in two years and dedicated on October 4, 1897, in a ceremony in its rotunda.

At the dawn of the 20th century, Low Memorial Library contained the undergraduate reading room, Avery Architectural Library, the Law Library, conference and seminar rooms, the dean's and president's offices, and the Trustees Room. In 1934, with the completion of South Hall (now Butler Library), the entire building was relegated to the administrative and ceremonial functions it still serves today.

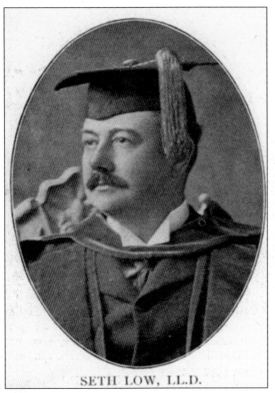

SETH LOW, LL.D.

The man behind the move to Morningside Heights was university president Seth Low (1850–1916), who ascended to the presidency a mere 20 years after receiving his degree as valedictorian of Columbia College in 1870. Equally impressive was his four-year term as mayor of Brooklyn from 1882 to 1886. In 1902, he resigned from the university's presidency to become second mayor of the consolidated City of New York.

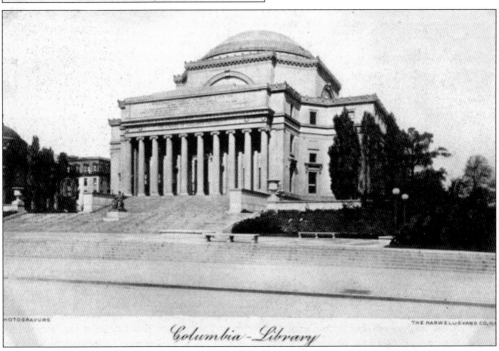

Columbia-Library

Set upon the highest plateau in Morningside Heights, Low Memorial Library is the centerpiece of Columbia's campus atop the steps of the South Court fronting West 116th Street. In this view from about 1905, it is joined at left by a remnant of the Bloomingdale Asylum, West Hall.

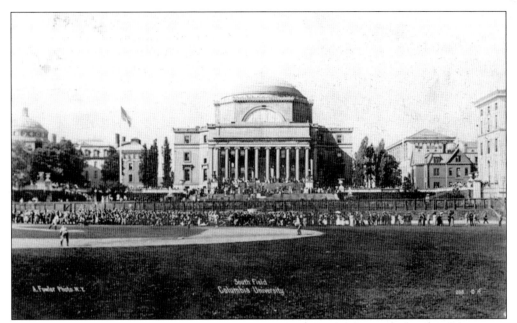

Perched majestically above South Field on a late spring day in 1913, Low Memorial Library fronts the academic buildings of the Upper Quadrangle. South Field, bought by the university in 1903, was devoted to use as an athletic facility for such sports as tennis, baseball, football, and track until the sports stadium and facilities at Baker Field were built in 1922.

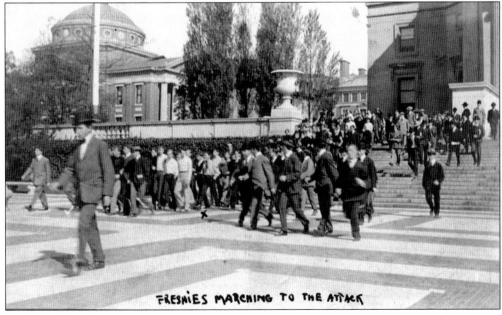

What makes freshies attack? The October 1905 postmark places this image at the beginning of the first half-year (fall term) during the freshman-sophomore "scraps." These included such contests as the historic flag rush, tug-of-war, and the rope tie, where warring classes were given pieces of rope and attempted to tie the feet and arms of as many opponents as possible. (Collection of Bob Stonehill.)

This magnificent view from 1902 dramatically juxtaposes the Macy Villa (built in 1885) remaining from the Bloomingdale Asylum (in the foreground) with Low Memorial Library, crowned by the largest solid masonry dome in America at the time. Called College Hall at the time the postcard was printed and located on West 116th Street, the villa was moved to the Upper Quadrangle in 1905 and stripped of its porches. Since then its name has changed to East Hall then Alumni House and currently Buell Hall.

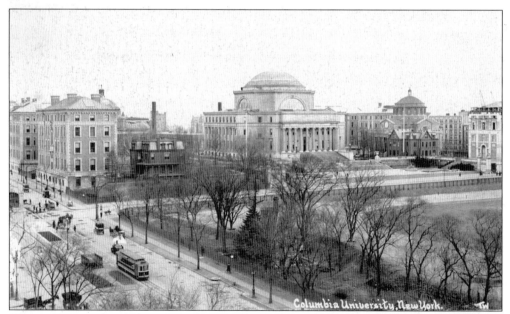

Columbia University, New York.

On a walk or carriage ride up Broadway in 1910, one would find the gatekeeper's lodge of the Bloomingdale Asylum (bottom center), built in 1879, where Furnald Hall meets Journalism Hall today. This is the first of several postcards photographed by Thaddeus Wilkinson used in this book—look for his trademark "TW" in the lower right corner.

This view dates from 1903. It was taken from Amsterdam Avenue at West 116th Street looking northwest. On the far right, Fayerweather and Schermerhorn Halls, both built in 1896, form the northeastern corner of the Upper Quadrangle and are raised above the street level to maintain a uniform grade.

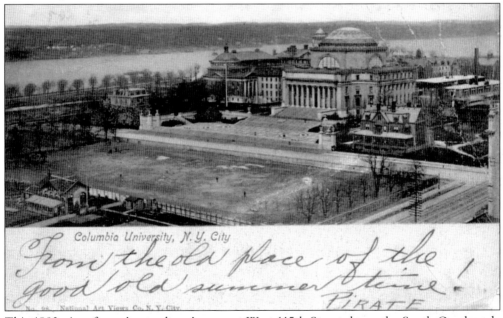

Columbia University, N. Y. City

This 1903 view from Amsterdam Avenue at West 115th Street shows the South Quadrangle in the foreground. The transitional nature of the campus at that time is clear. Low Memorial Library stands among four of the remaining structures of the Bloomingdale Asylum: the athletic field house on South Field; South Hall at West 116th Street close to Broadway; West Hall, to the right of Earl Hall (built in 1902); and College (East) Hall.

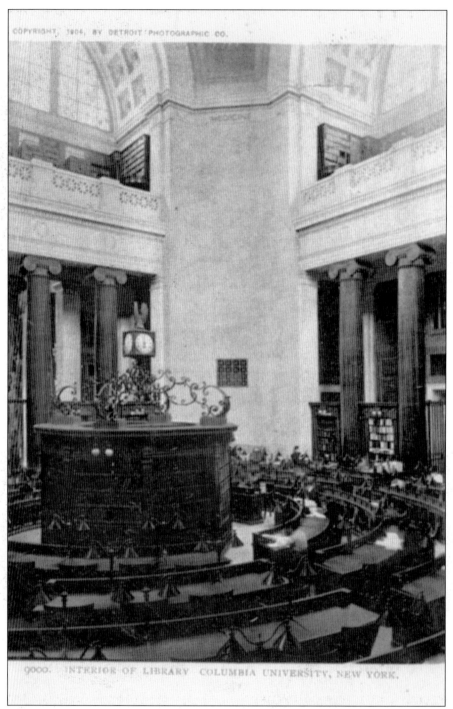

9000. INTERIOR OF LIBRARY COLUMBIA UNIVERSITY, NEW YORK.

Shown in 1904, the rotunda of Low Memorial Library originally housed the reference desks and main reading room. The four-faced clock in the center of the room was given to the library four years earlier by the class of 1874. The rotunda is now used for distinguished lectures and ceremonies. Evidence of its use as a library may still be found today in the galleries at the attic level on the fourth floor.

16

The New York-based architectural firm of McKim, Mead and White was chosen to develop the master plan for the university in 1893. Already the largest firm in America, it was best known for its shingle-style houses, its work on the Boston Public Library, and its contributions to the World's Columbian Exposition in Chicago in that same year.

CHARLES FOLLEN McKIM

WILLIAM RUTHERFORD MEAD

STANFORD WHITE

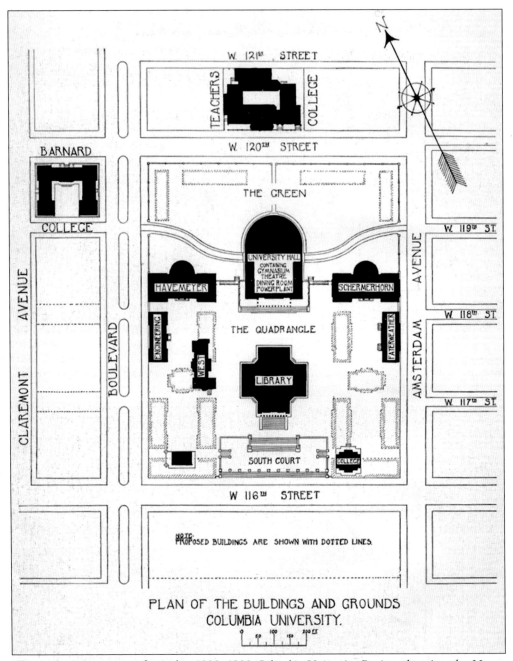

PLAN OF THE BUILDINGS AND GROUNDS
COLUMBIA UNIVERSITY.

This is the campus map from the *1898–1899 Columbia University Register* showing the Upper Quadrangle and Green with extant and proposed buildings of McKim, Mead and White's master plan. Barnard College is across the Boulevard to the west while Teachers College is above West 120th Street.

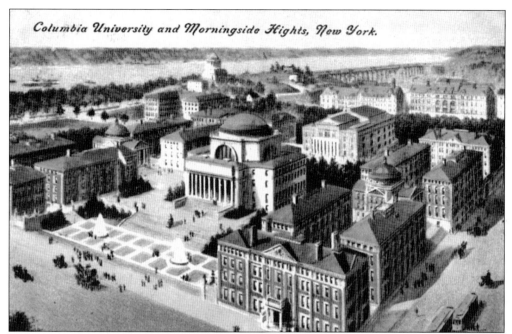

Columbia University and Morningside Hights, New York.

The multiple quadrangle approach to building on the Upper Quadrangle is shown in this aerial perspective illustration from 1906. If built to this plan, the Upper Quadrangle would currently have three more buildings than it does. Only the northeast quadrangle was completed according to plan, and the Macy Villa (College Hall) was spared demolition.

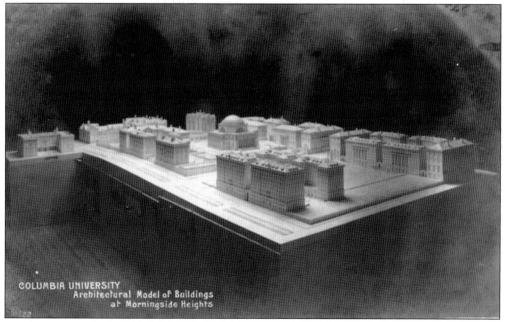

Displayed at McKim, Mead and White's Columbia Pavilion at the 1904 St. Louis World's Fair, this architectural model of the Columbia, Barnard, and Teachers College campuses expands upon the plan above by including the buildings proposed for the recently purchased South Quadrangle. It is unclear why four buildings are missing or removed.

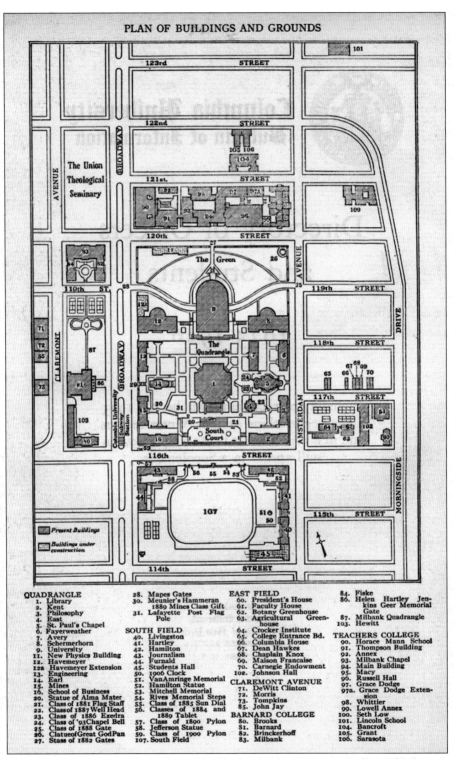

PLAN OF BUILDINGS AND GROUNDS

QUADRANGLE
1. Library
2. Kent
3. Philosophy
4. East
5. St. Paul's Chapel
6. Fayerweather
7. Avery
8. Schermerhorn
9. University
11. New Physics Building
12. Havemeyer
12a. Havemeyer Extension
13. Engineering
14. Earl
15. Mines
16. School of Business
20. Statue of Alma Mater
21. Class of 1881 Flag Staff
22. Class of 1887 Well Head
23. Class of 1886 Exedra
24. Class of '93 Chapel Bell
25. Class of 1888 Gate
26. Clatue of Great God Pan
27. Stass of 1882 Gates
28. Mapes Gates
30. Meunier's Hammeran 1889 Mines Class Gift
31. Lafayette Post Flag Pole

SOUTH FIELD
40. Livingston
41. Hartley
42. Hamilton
43. Journalism
44. Furnald
45. Students Hall
50. 1906 Clock
51. VanAmringe Memorial
52. Hamilton Statue
53. Mitchell Memorial
54. Rives Memorial Steps
55. Class of 1885 Sun Dial
56. Classes of 1884 and 1889 Tablet
57. Class of 1890 Pylon
58. Jefferson Statue
59. Class of 1900 Pylon
107. South Field

EAST FIELD
60. President's House
61. Faculty House
62. Botany Greenhouse
63. Agricultural Greenhouse
64. Crocker Institute
65. College Entrance Bd.
66. Columbia House
67. Dean Hawkes
68. Chaplain Knox
69. Maison Francaise
70. Carnegie Endowment
102. Johnson Hall

CLAREMONT AVENUE
71. DeWitt Clinton
72. Morris
73. Tompkins
85. John Jay

BARNARD COLLEGE
80. Brooks
81. Barnard
82. Brinckerhoff
83. Milbank
84. Fiske
86. Helen Hartley Jenkins Geer Memorial Gate
87. Milbank Quadrangle
103. Hewitt

TEACHERS COLLEGE
90. Horace Mann School
91. Thompson Building
92. Annex
93. Milbank Chapel
94. Main Building
95. Macy
96. Russell Hall
97. Grace Dodge
97a. Grace Dodge Extension
98. Whittier
99. Lowell Annex
100. Seth Low
101. Lincoln School
104. Bancroft
105. Grant
106. Sarasota

Shown here is a campus map from the *1925–1926 Columbia University Bulletin of Information and Directory of Officers and Students.*

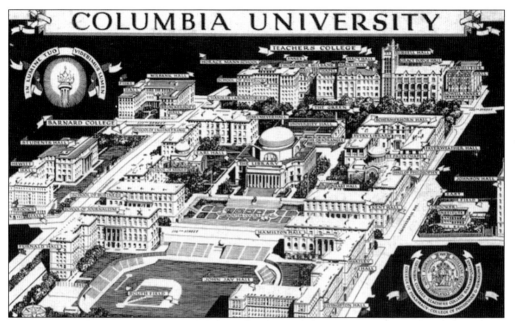

In this rendered view of the campus from the mid-1920s, it is already evident that the campus is becoming crowded. Except for Uris Hall (the second home of the School of Business) built above University Hall between 1959 and 1964, there have been no new buildings on the Upper Quadrangle since that time. The School of Physics (later Pupin Physics Laboratories) and John Jay Hall, both built between 1925 and 1927, were the most recent additions to campus at the time the postcard was made.

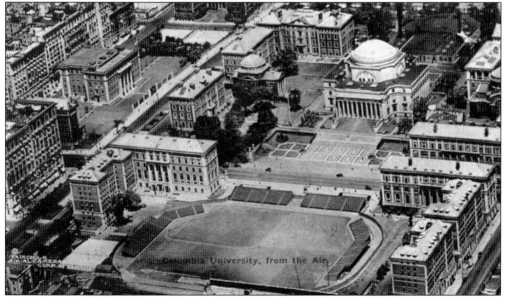

This view was taken a few years earlier as the School of Business (built from 1923 to 1924, and later called Dodge Hall), John Jay Hall, the School of Physics, and Hewitt Hall (built in 1924) at Barnard are missing. The athletic field, surrounded by bleachers, is where Lou Gehrig, Columbia's most eminent dropout since Alexander Hamilton, played baseball and football while enrolled in the college from 1921 to 1922.

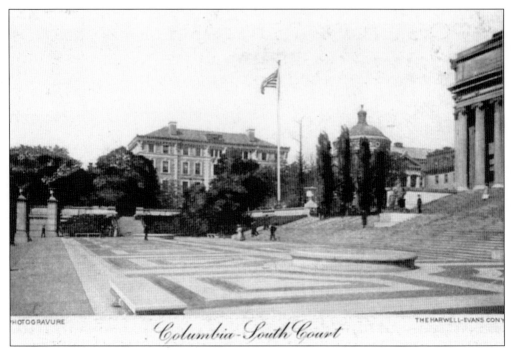

Columbia-South Court

The geometry of brick on the South Court (in this *c.* 1904 view) is relieved by the trees and plantings along the walls of the Upper Quadrangle, as they were well into the 1980s. The ancient yew trees flanking the pink granite steps were transplanted from Columbia's midtown campus.

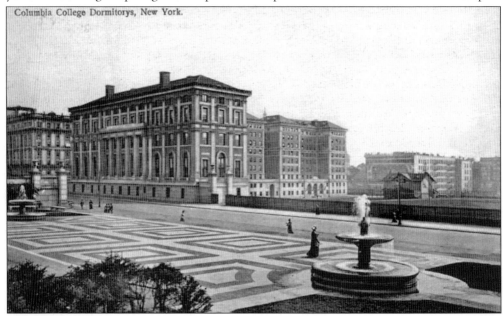

Columbia College Dormitorys, New York.

This 1907 image from the South Court across West 116th Street shows the first buildings on the South Quadrangle—Hamilton (built from 1905 to 1907), Hartley, and Livingston (built from 1904 to 1905) Halls. The pink granite fountains, based on those in the Piazza Vaticana in front of St. Peter's Basilica, had been recently erected through a gift of Marcellus Hartley Dodge, class of 1903.

22

Two

CAMPUS TOUR
UPPER QUADRANGLE AND THE GREEN

The hilly topography of Morningside Heights lent itself to McKim, Mead and White's vision of an elevated campus placed upon a terrace, with buildings focused inward toward campus rather than facing the street. The master plan for the 17-acre site initially purchased made Low Memorial Library its monumental centerpiece, joining an east-west axis composed of St. Paul's Chapel and Earl Hall, with the principal north-south axis across the plaza. The academic buildings were to form quadrangles in each quadrant of this biaxial plan on the lower two-thirds of the site, from West 116th to West 119th Streets. To the north of this, the land remained 25 feet below the terraced campus. With a winding drive and tree-lined pathways, it was known as the Green, the venue for many a commencement ceremony during Columbia's first years on Morningside Heights.

From the first laying of the cornerstone for Low Memorial Library in 1895, the campus, from the Green south to West 116th Street, took less than 30 years to develop. Two of the three remaining buildings of the Bloomingdale Asylum, South Hall and West Hall, were razed during this time while the third, the Macy Villa (now Buell Hall), was moved to its present location. The academic buildings, beginning with Schermerhorn, Havemeyer, Fayerweather, and the School of Engineering (now Mathematics), all completed by 1897, were soon joined by Earl Hall, St. Paul's Chapel, and five additional academic buildings. St. Paul's Chapel and the School of Mines (now Lewisohn Hall) are the only Columbia buildings not attributable to McKim, Mead and White in the period from 1895 to 1929. The construction of Avery Hall in 1912 completed the only one of McKim, Mead and White's academic quadrangles to be built as planned. By the 1930s, this portion of the upper campus was referred to collectively as the Upper Quadrangle.

Encroachment onto the Green was inevitable and began with University Hall in 1899. Chandler Laboratories, Schermerhorn Extension, and the School of Physics (now Pupin Hall) were added in the 1920s. Further building in the mid-to-late 20th century has obliterated the Green and elevated that portion of campus well above West 120th Street.

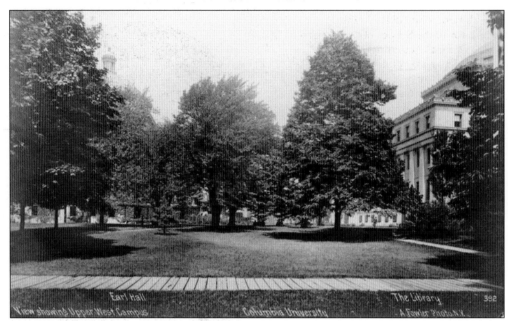

As one walks up the west stairs from South Court to the Upper Quadrangle around 1910, one finds a sprawling lawn adjacent to the old South Hall of the Bloomingdale Asylum. The magnificent trees obscure Earl Hall (left) and Low Memorial Library.

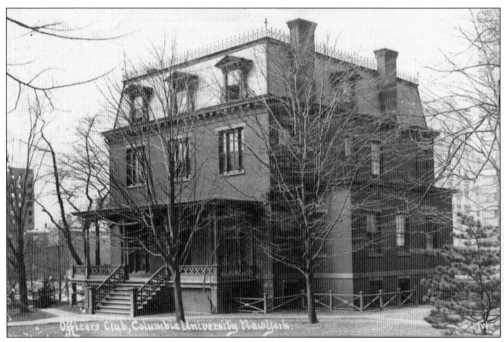

Old South Hall was known as the Men's Faculty Club, or the Officer's Club, during much of the first two decades of the 20th century. Before this, it housed the Department of Music until 1905. The first meeting of the Men's Faculty Club was held in 1906. The Officer's Club was demolished in 1922 to make way for the School of Business (now Dodge Hall). (Collection of Bob Stonehill.)

Adolph Lewisohn (1849–1938), benefactor of the School of Mines, gave the funds for the building that would later bear his name on the condition that Arnold Brunner, a prominent Jewish architect, design the building. A German immigrant, Lewisohn was a copper producer, art collector, and philanthropist who wished to advance the science of mining and metallurgy.

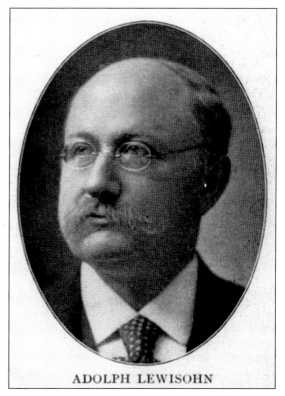

ADOLPH LEWISOHN

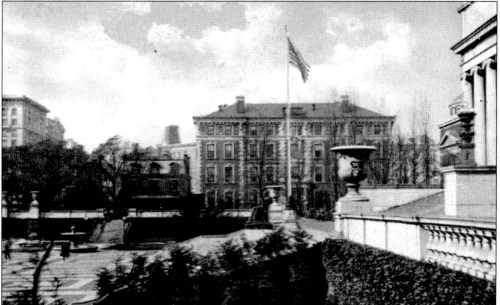

This view shows the School of Mines as seen from the east parapet of the Upper Quadrangle wall in the second decade of the 20th century. This building originally housed the Egleston Library of Mines and Engineering and the Museum and Department of Metallurgy. Besides St. Paul's Chapel, it was the only building not built by McKim, Mead and White in the first three decades of the campus's existence.

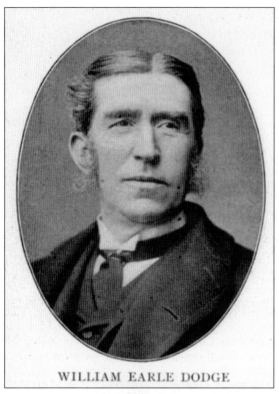

WILLIAM EARLE DODGE

William Earl Dodge (1805–1883) was one of the founders of Phelps, Dodge and Company, a leading mining company, and was instrumental in organizing the Young Men's Christian Association (YMCA). In 1900, as a gift in memory of his son, he provided the university with Earl Hall, a religious and social activity center under the management of the YMCA.

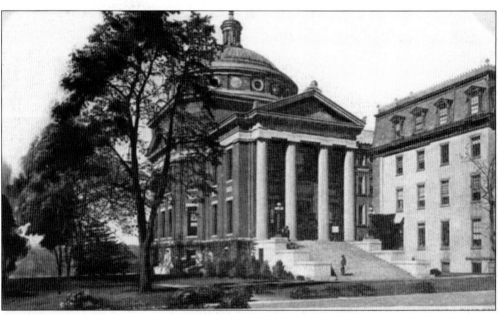

As one walks north from the School of Mines, Earl Hall (built from 1900 to 1902) appears, flanked by West Hall from the Bloomingdale Asylum. This view was taken two years after Earl Hall's dedication. The frieze above the portico reads "Erected for the students that religion and learning may go hand in hand and character grow with knowledge." The university assumed control over Earl Hall's management in 1922.

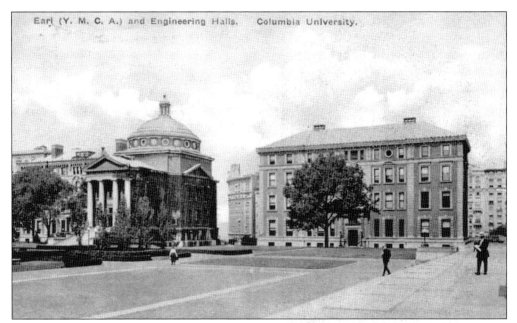

Continuing north from Earl Hall is the lawn fronting the School of Engineering, which was cleared by the razing of West Hall in 1913. The view is looking west from the steps in front of University Hall. The buildings behind the School of Engineering are on Claremont Avenue, and the young sycamore before it still stands.

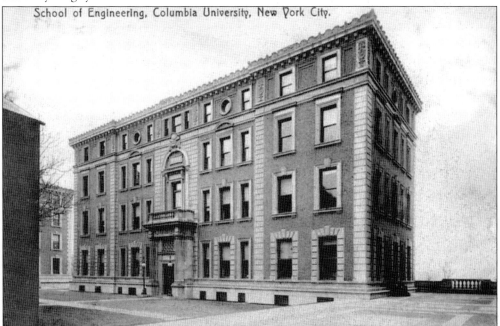

School of Engineering, Columbia University, New York City.

The School of Engineering, built from 1896 to 1897, was one of the first four buildings built to frame Low Memorial Library on the north. Originally housing the departments of Civil, Mechanical, Mining, and Electrical Engineering, it is now called Mathematics Hall. Moving closer to the building, one can explore McKim, Mead and White's sumptuous Italian Renaissance design, utilizing overburned Harvard brick and Indiana limestone throughout the Morningside campus.

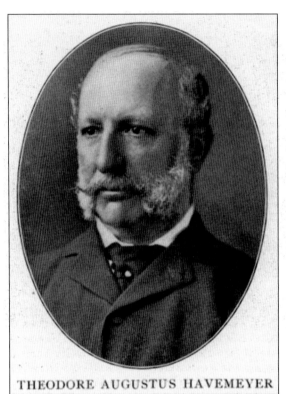

Theodore A. Havemeyer (1839–1897), School of Mines class of 1868, whose family name was long synonymous with sugar refining in New York, provided the $500,000 to build Havemeyer Hall in 1896, in honor of his father, Frederick Christian Havemeyer, who was a member of Columbia College's class of 1825.

THEODORE AUGUSTUS HAVEMEYER

A walk down the steps behind Havemeyer Hall leads to the Green at the north end of campus. The view from Broadway at West 119th Street in 1907 shows the semicircular projection of 309 Havemeyer Hall, Columbia's most impressive classroom. The Mapes Memorial Gates, at the entrance to the Drive through the Green, were erected in 1897. Although the gates and Green have been obliterated by subsequent construction, the Drive through the upper campus remains.

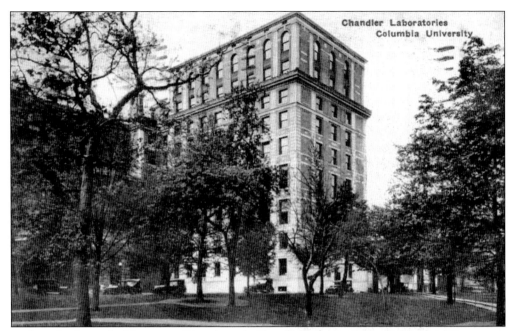

Back on the Green, looking toward Broadway, is Chandler Laboratories, an extension of Havemeyer Hall built between 1925 and 1928. It was one of the first three buildings built on the Green in Columbia's expansion northward. The others were Schermerhorn Extension (built from 1928 to 1929) and the School of Physics (built from 1925 to 1927 and now called Pupin Hall).

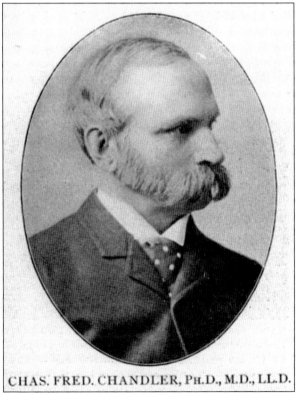

Charles Frederick Chandler (1836–1925), professor of chemistry at Columbia and dean of the School of Mines, was a leading industrial chemist and former president of New York City's health department. His name was linked to the laboratories in the extension building, but he was largely instrumental in the planning and construction of Havemeyer Hall. It did not hurt to have a close friend in Theodore A. Havemeyer.

CHAS. FRED. CHANDLER, Ph.D., M.D., LL.D.

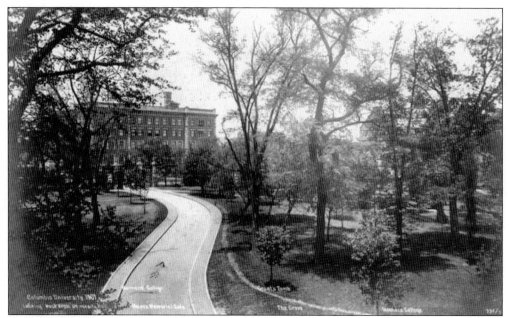

Strolling through the Green, one spies Barnard College's Brinckerhoff Hall (built from 1896 to 1897 and now part of Milbank Hall) through the clearing to the west across Broadway between West 119th and West 120th Streets. It is 1907, and if one looks hard, one can see Grant's Tomb (built from 1890 to 1897) and the Horace Mann School (built from 1899 to 1901) at Teachers College behind the trees.

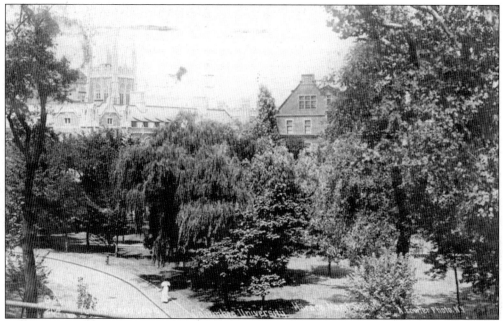

Seven years later, in 1914, the buildings of the Union Theological Seminary (built from 1906 to 1910) appear over the trees at Broadway and West 120th Street. The James Memorial Chapel Tower, in the upper left, is on Claremont Avenue. Ten years later, the School of Physics building would be placed in this bucolic spot on the Green, a veritable skyscraper at 14 stories.

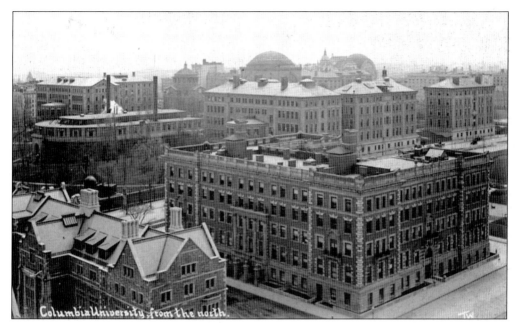

Another magnificent Thaddeus Wilkerson view takes one high above the street at Claremont Avenue and West 120th Street to look south over the Green and Upper Quadrangle. The buildings of Union Theological Seminary and Barnard College make up the foreground, while the domes of St. Paul's Chapel, Low Memorial Library, St. Luke's Hospital, and the Cathedral Church of St. John the Divine are in the background.

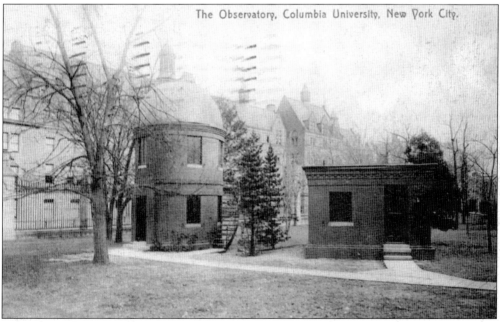

The Wilde Observatory occupied the northwest corner of the Green, known as the Grove, where it was hidden by dense greenery. Built in 1907, it was presumably made obsolete by the erection of the Rutherfurd Astronomical Observatory atop the School of Physics building in 1927. (Collection of Bob Stonehill.)

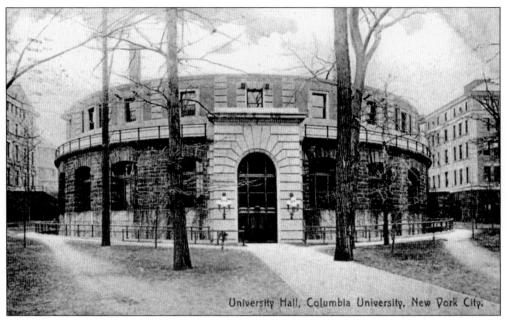

University Hall, Columbia University, New York City.

Heading east on the Green from Broadway to Amsterdam Avenue in 1908, one encounters University Hall. When construction first began on the building in 1896, it was meant to be several stories taller, but when funds were no longer available it was left unfinished. Notice the steps down to the Green from Schermerhorn Hall on the left and Havemeyer Hall on the right. Today the library of the Columbia Business School mimics the semicircular shape of the original first floor above campus.

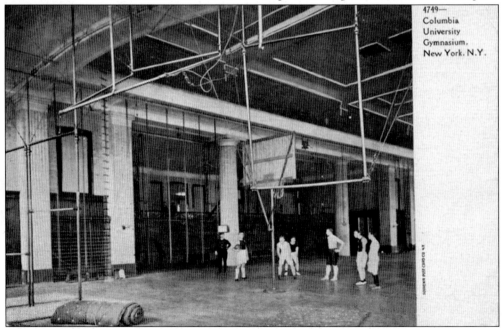

4749—
Columbia
University
Gymnasium.
New York. N.Y.

This is a view of the basketball courts in the old gymnasium in University Hall with the running track above, similar to how it looks today. A century after this postcard was made, the grand staircases and Doric columns still grace the athletic facilities. Columbia Business School's Uris Hall now lies above this portion of University Hall.

Finishing the walk east along the Drive one ends up at Amsterdam Avenue and West 119th Street, where it appears workers are preparing to install the class of 1888 gates. It is 1914, and the buildings of Teachers College are visible from beyond the northern border of Columbia's campus.

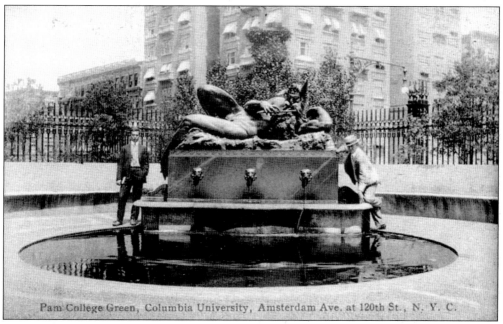

Pan College Green, Columbia University, Amsterdam Ave. at 120th St., N. Y. C.

A quick detour to the northeast corner of the Green at West 120th Street and Amsterdam Avenue brings one to the *Great God Pan* by George Gray Barnard. Originally executed in 1898 as the largest single bronze casting ever, it came to Columbia in 1907 with a fountain below and a pink granite exedra in back. Pan now plays his reed pipe on Lewisohn Lawn, without the fountain, exedra, or some say, a fig leaf.

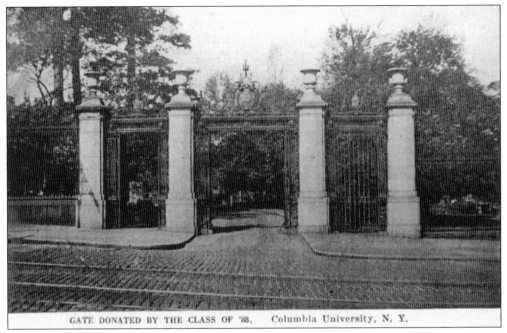

GATE DONATED BY THE CLASS OF '88. Columbia University, N. Y.

This is a view across the trolley tracks of Amsterdam Avenue at West 119th Street west looking toward the Green. The class of 1888 gates were presented by the Schools of the Arts and Mines and designed by School of Mines class member Arthur Stoughton. The north gate is devoted to science while the south gate is devoted to the arts.

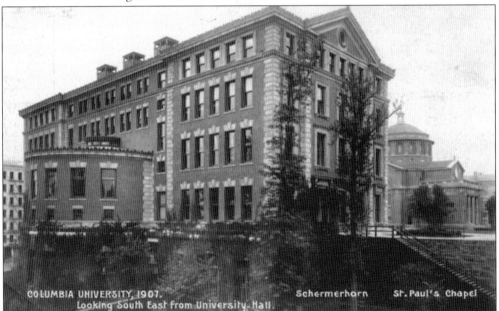

COLUMBIA UNIVERSITY, 1907. Schermerhorn St. Paul's Chapel
Looking South East from University Hall.

This view shows the west side of the campus after entering the class of 1888 gates, 25 feet below the Upper Quadrangle at Schermerhorn Hall, already 10 years old in 1907. Almost a mirror image of Havemeyer Hall on the east side of the campus, it also has a semicircular projecting classroom. Before the addition of Avery Hall (built from 1911 to 1912), the camera angle makes it look as if St. Paul's Chapel is right next door.

William Colford Schermerhorn (1821–1903), a graduate of Columbia College in 1840, became a lawyer in 1842 and was made chairman of the board of trustees in 1893. He gave the university the $300,000 needed to build a general science building, the second bequest on the Morningside campus after Seth Low's. The inscription above the entrance to Schermerhorn Hall reads, "For the advancement of natural science—Speak to the earth and it shall teach thee."

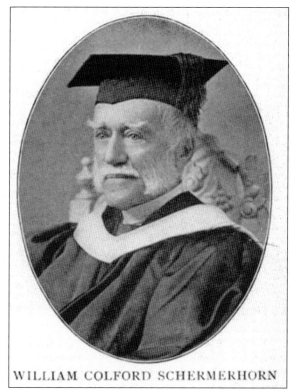

WILLIAM COLFORD SCHERMERHORN

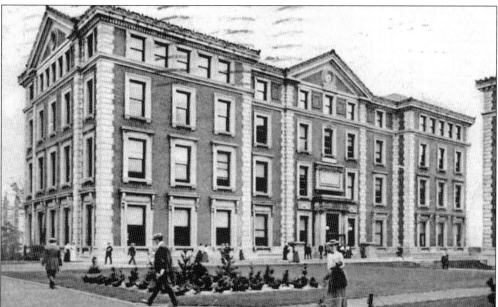

As one ascends to view Schermerhorn Hall from the campus level on a busy day in 1903, current Columbians might ask themselves "how does a building with four visible floors have an art history department on the eighth and ninth floors?" Of course, one enters on the fourth floor from the upper campus, three floors are below campus level (see lower image on page 34). The answer to the question is in the addition of two floors, five and seven, in 1946 and 1947.

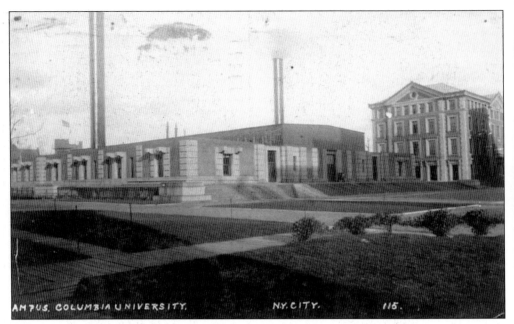

When standing behind Low Memorial Library and looking east toward Schermerhorn, it is possible to see this terrific campus-level view of University Hall in 1914, only months before a fire would destroy the wooden superstructure. The first floor above campus level contained the bursar, university admissions, and department of buildings and grounds. Notice the smokestacks from the original physical plant, which is still located below campus here.

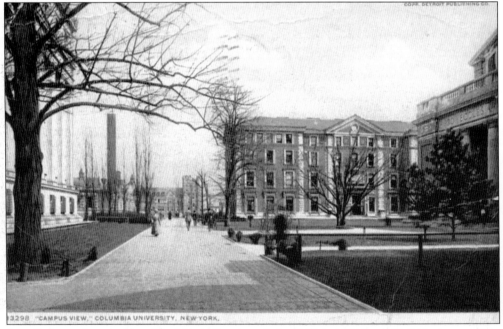

A walk down the east side of the Upper Quadrangle in 1909 and 1910 would find a large empty lawn in front of Schermerhorn, which was soon to be the site of Avery Hall. St. Paul's Chapel is on the right, Low Memorial Library is on the left, and not far off in the distance is a relatively unobstructed view of the buildings of Teachers College.

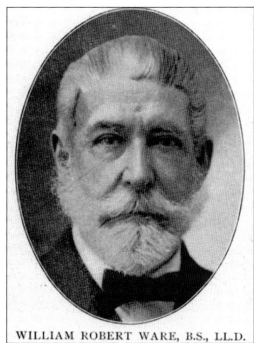 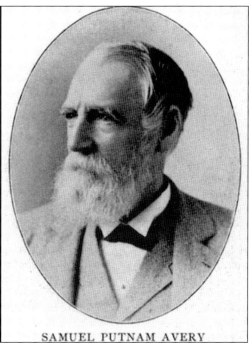

WILLIAM ROBERT WARE, B.S., LL.D. SAMUEL PUTNAM AVERY

William Robert Ware (1832–1915) founded the School of Architecture in 1880 as a department in the School of Applied Science. In 1890, New York art dealer Samuel Putnam Avery (1822–1904) and his wife established Avery Architectural Library, previously housed in Low Memorial Library, in memorial to their son, Henry Ogden Avery, an architect.

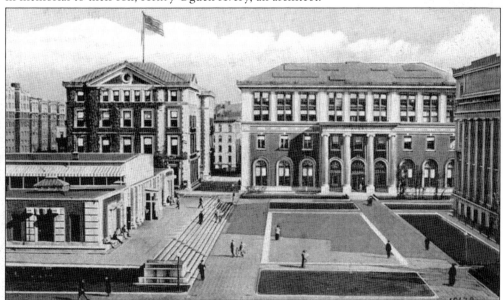

Built to house the Avery Architectural Library and the School of Architecture, Avery Hall was completed in 1912. It is situated just to the left of Low Memorial Library in this view. Built with an additional bequest from Avery's widow, the building was finished a year after her death. Avery was the only hall built to complete one of the four planned quadrangles on the Upper Quadrangle as shown in the model on page 19.

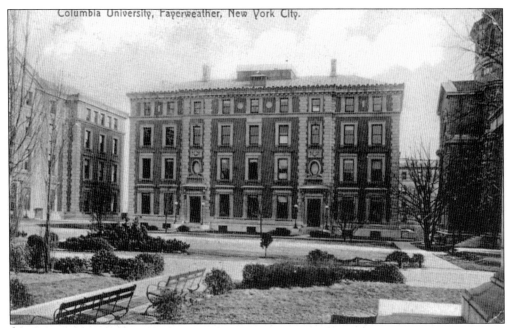

Looking east from behind Low Memorial Library in 1905, it is possible to see the only McKim, Mead and White building, Fayerweather Hall, on Morningside with two campus-level entrances. Built in 1896 in honor of Daniel B. Fayerweather, a liberal benefactor of education, the hall was originally devoted to the Department of Physics.

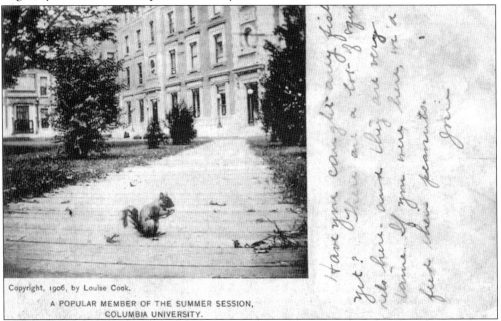

Copyright, 1906, by Louise Cook.

A POPULAR MEMBER OF THE SUMMER SESSION,
COLUMBIA UNIVERSITY.

Columbia has had many campus "characters" over the years—the "Chihuahua" lady, Sam Steinberg (the "Baby Ruth" man), and professors who would endeavor to say hello to every undergraduate. The only campus characters today are the squirrels. This is shared with the first Columbians on Morningside Heights; this squirrel is on the wooden planks leading to Fayerweather in 1906.

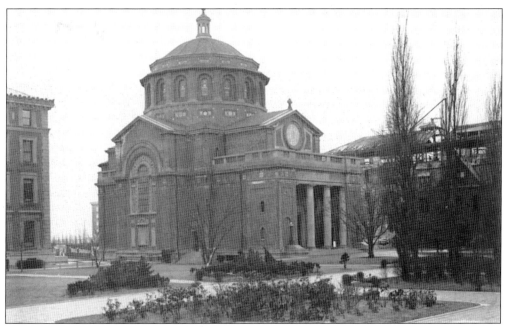

This view looks southeast toward St. Paul's Chapel (built from 1903 to 1907) from the steps of University Hall in this Thaddeus Wilkerson image from 1909 or 1910. Architects Isaac Newton Phelps Stokes and John Mead Howells designed the chapel for Olivia Egleston Phelps Stokes and Caroline Phelps Stokes in honor of their parents, banker James Stokes and Caroline Phelps, heiress to the Ansonia copper fortune. Kent Hall is under construction at the right.

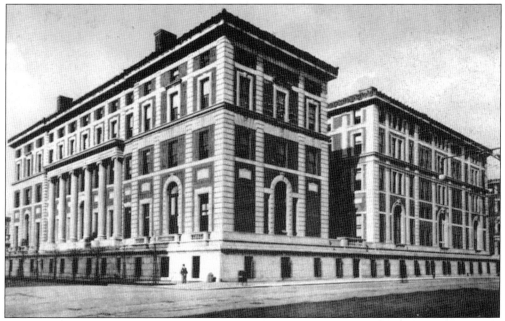

Looking northeast from Amsterdam Avenue and West 116th Street is Kent Hall (built in 1910), on the left, which originally housed the School of Law and was named for James Kent, first professor of law in Columbia College. Next to Kent Hall is Philosophy Hall (built in 1911), the gift of Helen Hartley Jenkins, which was built for the faculty of philosophy.

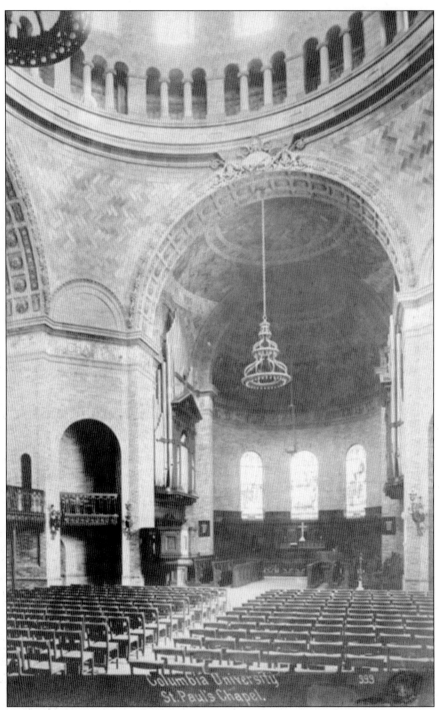

The dome of St. Paul's Chapel soars to a height of 91 feet, and the vaulting beneath is covered with Guastavino tiles. The walls are of a salmon-colored brick, and the floor is of a marble terrazzo with yellow marble from a demolished Roman church. The organ is the work of the Ernest M. Skinner Company, and the three windows in the apse were executed by John LaFarge. The University Bell, a gift of Columbia College's class of 1893, resides in the portico.

Three

CAMPUS TOUR
SOUTH QUADRANGLE AND EAST QUADRANGLE

Columbia purchased the land south of West 116th Street extending to West 114th Street from the New York Hospital in October 1903 for $1.9 million, 11 years after it purchased the Upper Quadrangle. Referred to as the South Quadrangle, it was first used as athletic fields for baseball, football, tennis, and track. This athletic area, called South Field, became more constrained as new buildings were constructed around it during the next three decades. Except for the buildings at the southwest corner (Carman, Ferris Booth, and Alfred Lerner Halls, all built in the latter half of the 20th century), this portion of campus was virtually as it appears today by 1934.

McKim, Mead and White extended the master plan to the South Quadrangle, envisioning two quadrangles devoted primarily to undergraduate education as the buildings of the Upper Quadrangle were increasingly dedicated to graduate study. An important element of the plan was the establishment of a new home for Columbia College with the completion of Hamilton Hall in 1907. The quadrangles were not built as planned, however. Columbia's first dormitories—Hartley and Livingston Halls (now called Wallach) were built in 1904 and 1905 after Pres. Nicholas Murray Butler decided to experiment with dormitories in an urban environment. Seth Low, president before Butler, had been determined to keep dormitories off the campus, believing that Columbia students should live in neighborhoods throughout the city. The experiment was apparently successful, and Furnald and John Jay Halls were built over the next two decades. In 1934, the South Quadrangle also became home to Low Memorial Library's successor, South Hall (now called Butler Library).

The East Quadrangle refers to the area from Amsterdam Avenue to Morningside Drive and from West 116th Street to West 117th Street, originally purchased in several lots from 1910 to 1914. The President's House and Johnson Hall (now called Wien Hall), both built in the 1920s, are among the older buildings on this part of campus. Over the years the East Quadrangle has expanded to West 118th Street and is now referred to as East Campus.

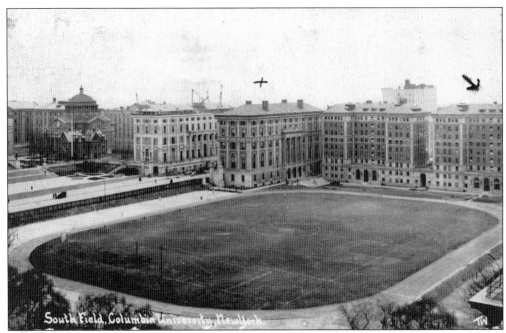

In this view from 1910 or 1911 of the South Quadrangle from Broadway and West 114th Street, one sees Hamilton, Hartley, and Livingston Halls. The athletic field is impressive in size after demolition of the field house left over from the Bloomingdale Asylum days. Kent and Philosophy Halls are nearing completion on the Upper Quadrangle.

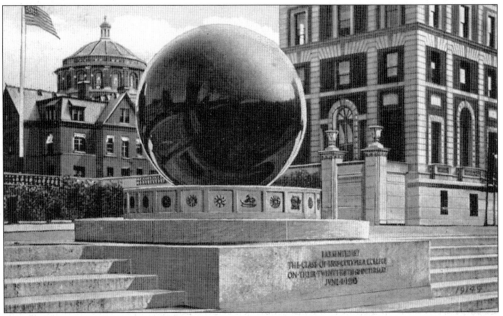

A walk across West 116th Street to the center of campus brings one to the Sun Dial, a dark green granite sphere sitting upon a circular pedestal. It used to tell the time only once per day, at noon. It was a gift of the class of 1885 and was presented to the university in 1914. Presumably in the interest of safety, the granite sphere was removed in 1946 when a crack developed.

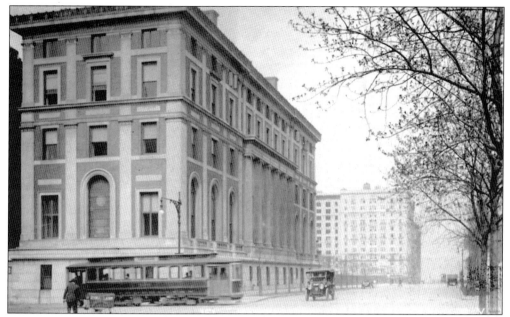

Continuing the tour along West 116th Street toward Amsterdam Avenue, this view looks back toward Hamilton Hall's north facade around 1910. Donated by university trustee John Stewart Kennedy and named for Alexander Hamilton, it has been the seat of Columbia College on Morningside Heights for 100 years.

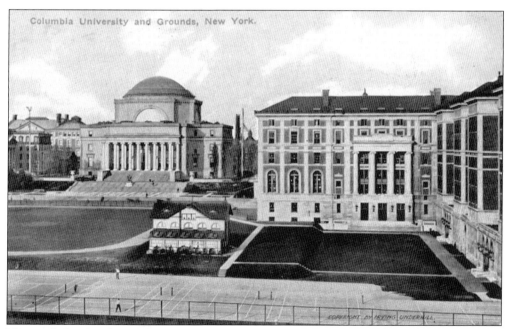

The south facade of Hamilton is viewed here from West 114th Street around 1908 prior to the expansion of the athletic field seen in a later view at the top of page 42. Although the firm of McKim, Mead and White would continue to design campus buildings until the late 1920s, Hamilton was the last of the university buildings to be designed by Charles Follen McKim himself.

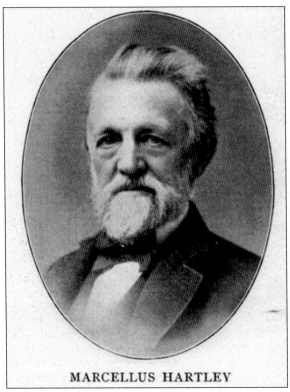

Marcellus Hartley (1827–1902), namesake of Hartley Hall (built from 1904 to 1905), was a brigadier general who procured arms for the Union army. He became one of the five wealthiest men in the country by acquiring the Remington Arms Company. His grandson Marcellus Hartley Dodge, class of 1903, with his aunt, Helen Hartley Jenkins, provided the $300,000 necessary to build the memorial to his grandfather.

MARCELLUS HARTLEY

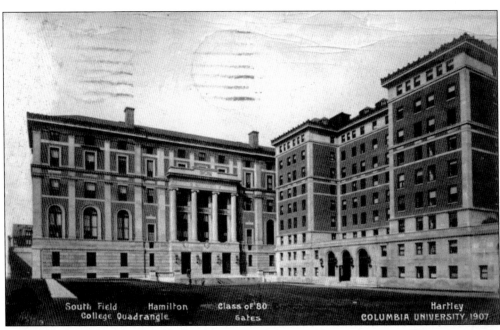

South Field Hamilton Class of '80 Hartley
 College Quadrangle Gates COLUMBIA UNIVERSITY, 1907

In 1902, when Nicholas Murray Butler assumed the presidency, he was willing to create a residential college, at least partially. Hartley Hall (right) was the first of the men's dormitories built on the Morningside campus. It would take another 86 years for the college to become fully residential.

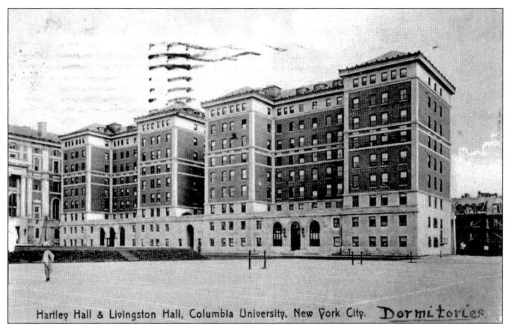

Hartley Hall & Livingston Hall, Columbia University, New York City. Dormitories.

Livingston Hall was built at the same time to the same design as Hartley Hall in 1904 and 1905, and stands directly south of it along Amsterdam Avenue in this 1908 postcard. It is a memorial to Robert R. Livingston, class of 1765, member of the Continental Congress, and drafter of the Declaration of Independence. After a renovation in the 1980s, Livingston Hall was rededicated as Wallach Hall.

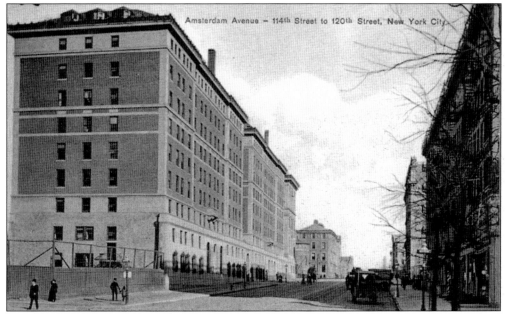

Amsterdam Avenue — 114th Street to 120th Street, New York City

Looking up Amsterdam Avenue at West 114th Street, it is possible to see the eastern facades of Livingston, Hartley, and Hamilton Halls from about 1910. In the left foreground is the land where John Jay Hall would rise 15 years later. The buildings on the right, or east, side of the street would later yield to the expansion of St. Luke's Hospital.

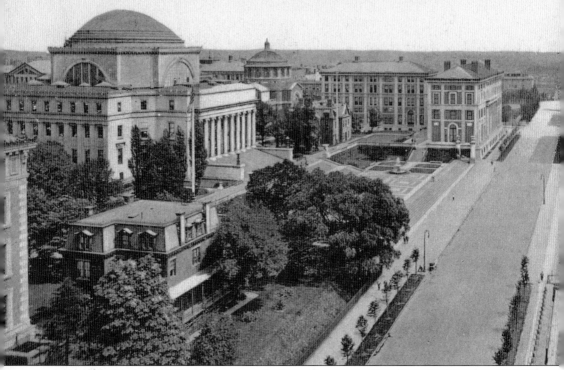

Bird's-Eye View of Columbia University, New York City.

This magnificent double-width postcard view of campus taken from the Rexor at 600 West 116th Street in 1912 looks directly across West 116th Street, which separates the Upper and South Quadrangles. West 116th Street is wider than most cross streets and still open to vehicular traffic. In fact, the street would not be closed and reconfigured as College Walk until 1954, Columbia's bicentennial year. In the foreground, the School of Journalism is under construction. It would

46

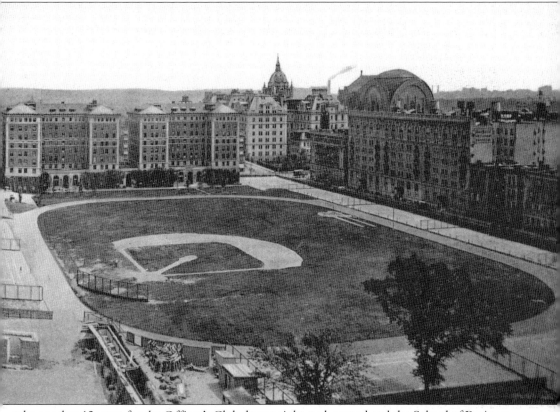

take another 12 years for the Officer's Club, lower right, to be razed and the School of Business (built from 1923 to 1924), now Dodge Hall, to be built. The domes of St. Luke's Hospital and the Cathedral Church of St. John the Divine can be seen on the upper right. (Used with permission of the University Archives, Columbia University in the City of New York.)

JOHN HOWARD VAN AMRINGE, Ph.D., LL.D.

John Howard Van Amringe (1835–1915), class of 1860, was dean of Columbia College "many a day" according to the inscription on his memorial. An ardent defender of the college during the consolidation of the university, he was also a professor of mathematics for 31 years prior to his deanship from 1896 to 1910.

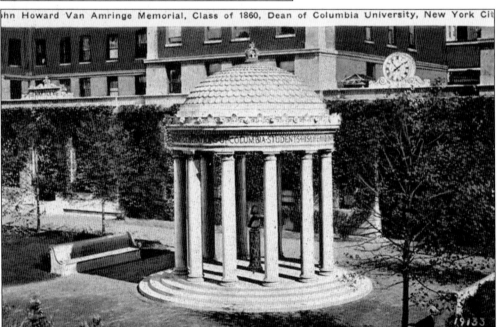

John Howard Van Amringe Memorial, Class of 1860, Dean of Columbia University, New York Cit

The Van Amringe memorial sits in front of the passageway between Hartley and Livingston Halls in the center of Hamilton quad. Designed by William Ordway Partridge, it was presented to the university on commencement day in 1922. The clock above the passageway, which still works, was presented by the class of 1906 in 1916.

Nicholas Murray Butler (1862–1947), class of 1882, succeeded Seth Low as university president in 1902. Butler was a master fund-raiser, raising funds for several halls, dormitories, and St. Paul's Chapel, as well as securing the land on the South Quadrangle for expansion. He was president for 44 years, retiring in 1946, at which time South Hall was named in his honor.

NICHOLAS MURRAY BUTLER, Ph.D., LL.D

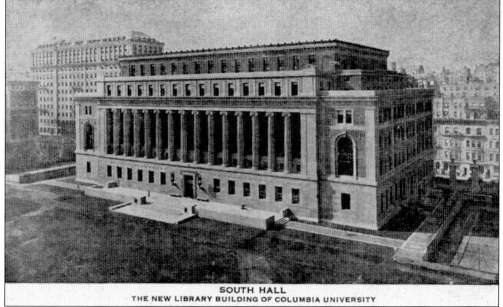

SOUTH HALL
THE NEW LIBRARY BUILDING OF COLUMBIA UNIVERSITY

Assuming the functions of the increasingly inadequate Low Memorial Library, South Hall (now Butler Library) forever terminated its predecessor's view south over Morningside Heights. It was built with $4 million donated by Edward Stephen Harkness, a graduate of the law school in 1928, whose name was given to a small, dark "academic theater" in the basement of the building, which has since been renovated out of existence.

FRANCIS PERKINS FURNALD

Furnald Hall was made possible by the bequest of Francis Perkins Furnald (1841–1907), and the cornerstone was dedicated by his widow, Sarah E. Furnald, in honor of their son, Royal Blackler Furnald, class of 1901.

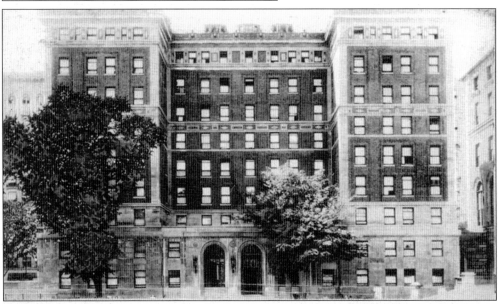

On the west side of South Field at West 115th Street is the third men's dormitory on the South Quadrangle, Furnald Hall (built from 1912 to 1913). Similar to Hartley and Livingston Halls in outward appearance, Furnald Hall was exceptional in that it housed showers, lockers, and dressing rooms for students who used the athletic fields. This space was later used for Furnald Grocery from 1976 to 1989. Traditionally a senior dormitory, it was reopened as a first-year and sophomore dormitory in 2001 after an extensive renovation in 1996.

Joseph Pulitzer (1847–1911), owner and publisher of the *New York World* and *St. Louis Post-Dispatch* was synonymous with "yellow journalism" and tried for years to establish the country's first school of journalism at Columbia but was rebuffed by Pres. Seth Low and the trustees. The school and the prizes named in his honor were established posthumously in 1912.

JOSEPH PULITZER

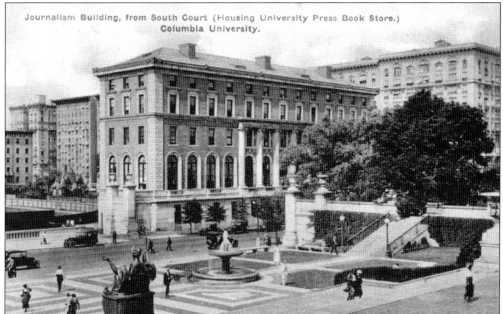

Journalism Building, from South Court (Housing University Press Book Store.) Columbia University.

This view looks southwest from the Low Memorial Library steps toward the School of Journalism (built in 1912 and 1913) on West 116th Street and Broadway around 1920. The building was erected and endowed in memory of Pulitzer's daughter, Lucille, and originally housed the Columbia University Press, a bookstore, and the Department of Music, as well as the Graduate School of Journalism.

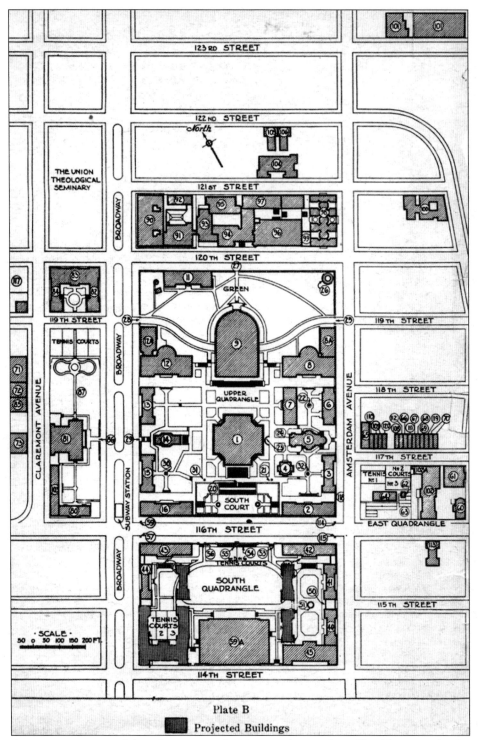

Plate B

▪ Projected Buildings

In this campus map and key from around 1938 are the results of building on the South Quadrangle over the prior 30 years and the proposals for further building, nearly all of which never occurred.

52

KEY

1 Low Memorial Library
2 Kent
3 Philosophy
4 Alumni House
5 St. Paul's Chapel
6 Fayerweather
7 Avery
8 Schermerhorn
8A Schermerhorn Extension
9 University Hall
11 Pupin Physics Laboratories
12 Havemeyer
12A Chandler Laboratories
13 Engineering
14 Earl
15 Mines
16 School of Business
20 Statue of Alma Mater
21 Class of 1881 Flag Staff
22 Class of 1887 Well Head
23 Class of 1886 Exedra
24 Class of '93 Chapel Bell
25 Class of 1888 Gate
26 Statue of Great God Pan
27 Class of 1882 Gates
28 Mapes Gate
29 Class of 1891 Gate
30 Meunier's Hammerman, 1889 Mines Class Gift
31 Lafayette Post Flag Pole
32 Rodin's Penseur
40 Livingston
41 Hartley
42 Hamilton
43 Journalism
44 Furnald
45 John Jay
50 1906 Clock
51 Van Amringe Memorial
52 Hamilton Statue
53 Mitchel Memorial
54 Rives Memorial Steps
55 Class of 1885 Sun Dial
56 Classes of 1884 and 1899 Tablet
57 Class of 1890 Pylon
58 Jefferson Statue
59 Class of 1900 Pylon
59A South Hall
60 President's House
61 Faculty House
62 Botany Greenhouse
63 Agricultural Greenhouse
64 East Hall
65 Casa Italiana
66 Geological Society of America, Inc.
67 Dean Hawkes
68 Chaplain Knox
69 Maison Francaise
70 Carnegie Endowment for International Peace
71 DeWitt Clinton
72 Morris
73 Tompkins
80 Brooks
81 Barnard
82 Brinckerhoff
83 Milbank
84 Fiske
85 Charles King
86 Helen Hartley Jenkins Geer Memorial Gate
87 Milbank Quadrangle
90 Horace Mann School
91 Thompson Hall
92 Annex
93 Milbank Chapel
94 Main Teachers College Hall
95 Macy Hall
96 Russell Hall
97 Grace Dodge Hall
98 Whittier Hall
99 Lowell Annex
100 Seth Low
101 Lincoln School
102 Johnson Hall
102A Women's Faculty Club
104 Bancroft
105 Grant
106 Sarasota
108 Deutsches Haus
109 College Entrance Examination Board
110 Casa de las Espanas
111 Dean Barker
112 Institute of International Affairs
113 King's Crown Hotel
114 Dwight Memorial Pylon
115 Pine Memorial Pylon
116 Class of 1880 Gates
117 Riverside Quad
118 Post Office
119 Dean Russell
120 International Institute of Social Research

The campus map also shows the growth of the East Quadrangle to the east of Amsterdam Avenue from West 116th and West 117th Streets.

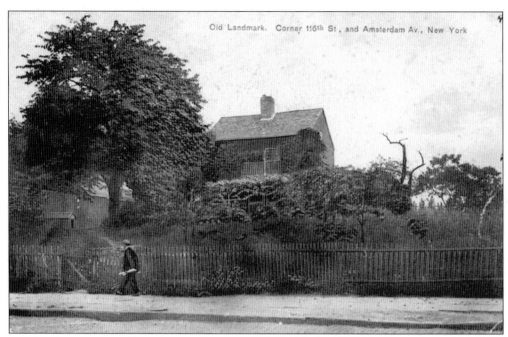

It is hard to imagine that this house stood at the northeast corner of West 116th Street and Amsterdam Avenue where the Jerome Greene Hall (built from 1995 to 1996) extension to the Columbia Law School (built from 1958 to 1961) stands today. This timber-framed remnant of an agrarian Morningside Heights gave way to the Crocker Research Laboratory of the Institute of Cancer Research in 1914.

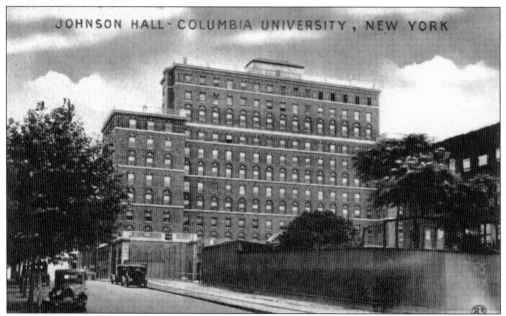

JOHNSON HALL - COLUMBIA UNIVERSITY, NEW YORK

Johnson Hall runs mid-block between Amsterdam Avenue and Morningside Drive from West 116th to West 117th Streets. Built as a graduate women's residence hall in 1924, it was named after the first president of King's College, Samuel Johnson, and his son, William Samuel Johnson, first president of the postrevolutionary Columbia College. In 1988, it was renamed Wien Hall.

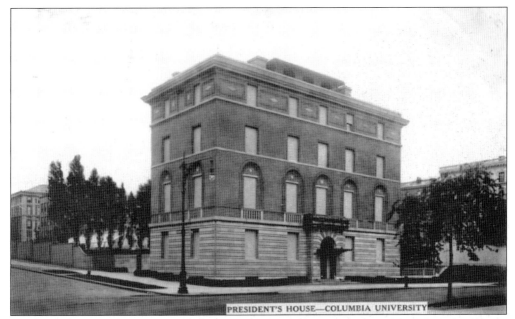

PRESIDENT'S HOUSE—COLUMBIA UNIVERSITY

This view shows the President's House on the northwest corner of Morningside Drive and West 116th Street around 1915, three years after Pres. Nicholas Murray Butler took up residence upon completion. From the far left are Philosophy Hall, Crocker Research Laboratory, and the Botany Greenhouse. The lot on the right would become Faculty House in 1923, home of the Men's Faculty Club.

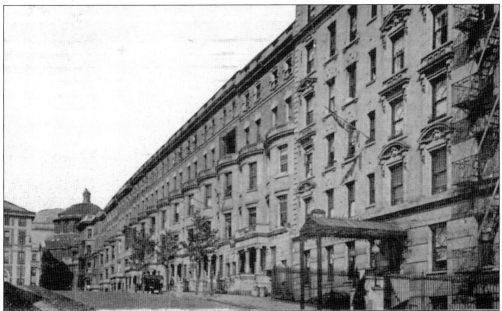

These townhouses were referred to as Dean's Row but also served as the location of the Maison Francaise, Deutches Haus, and the Casa de las Espanas. The Hotel LaPorte at the far corner (across from St. Paul's Chapel) was razed in 1926 for Casa Italiana (built from 1926 to 1927). The remainder of the townhouses were razed for the East Campus complex beginning with the School of International and Public Affairs (built from 1966 to 1970).

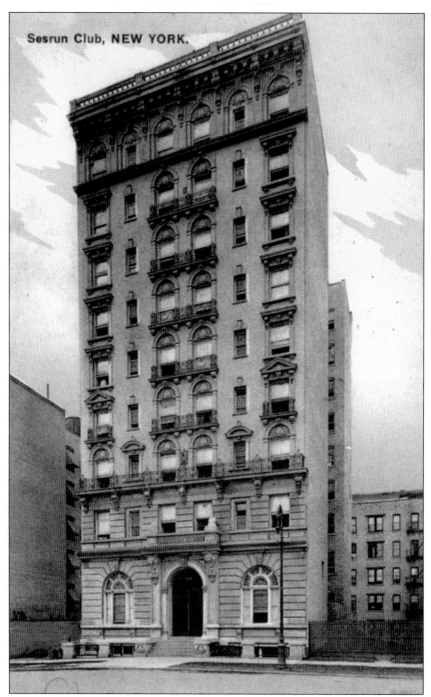

Sesrun Club, NEW YORK.

The Sesrun Club (nurses spelled backward) was established as a residence for nurses in this Neville and Bagge building at 420 West 116th Street. Presumably unsuccessful in this capacity, it appears in many postcards and advertisements in the decades to follow as the Westminster Hotel and the King's Crown Hotel. Currently it is home to the Deutsches Haus. Believe it or not, the 25-foot-wide lot to the left is now home to William Warren Hall (built in 1995 by Polshek and Partners), a law school building.

Four

BARNARD COLLEGE
WOMEN'S COLLEGE ON THE HEIGHTS

In 1879, Columbia president Frederick Augustus Porter Barnard told the trustees that Columbia should admit women to several of its lecture courses. Despite his persistence, it was not until 1883 that the trustees agreed to an experimental "Collegiate Course for Women." It was an experiment destined to fail. The enrolled women would meet with a professor at the beginning of the term to get the readings and would take the same examinations as the men at the end of the semester, but they were not allowed to attend the classes with men. During its four-year trial, 38 women enrolled, but only one attained the degree.

This failed experiment in coeducation was the impetus for the chartering of a separate women's college in 1889, named posthumously for Barnard, despite the fact that he did not believe in creating a separate institution for the education of women. The first day of classes for Barnard College was October 7, 1889, in a townhouse on Madison Avenue near Columbia's midtown campus. When Columbia planned its move to Morningside Heights, Barnard College was determined to follow, ultimately buying the one-acre plot between West 119th to West 120th Streets across the Boulevard from Columbia's Green for $160,000 in 1896. Barnard's first building, Milbank Hall, and its two wings, Brinckerhoff and Fiske Halls, were built immediately, and the college moved to Morningside Heights at the same time as Columbia in 1897. Additional acreage from West 116th to West 119th Streets was purchased in 1903, a gift of Elizabeth Milbank Anderson. It was referred to as the Milbank Quadrangle.

Although Barnard has always retained its own charter and trustees, it has been affiliated formally and integrated academically with Columbia University since January 1900. In fact, Barnard did not have its own president until 1953, when Millicent McIntosh, Barnard's fourth dean, assumed the position. Talks of merging with all-male Columbia College occurred sporadically, perhaps most heatedly in the early 1980s, prior to Columbia College's decision to admit women in 1983. Needless to say, Barnard College has entered the 21st century as a determinedly single-sex institution.

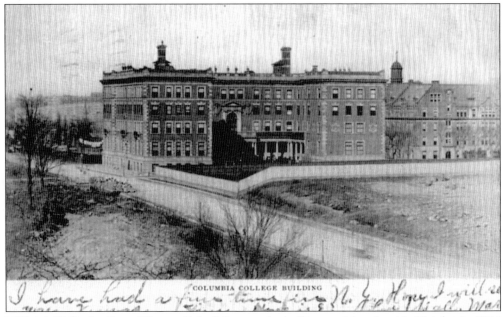

Milbank Hall, the first of Barnard's buildings to be built upon Morningside Heights in 1896 from a design by the architectural firm Lamb and Rich, was the gift of Elizabeth Milbank Anderson. It is actually the center portion of the building inaccurately labeled in this image. The east wing is Brinckerhoff Hall, the west wing is Fiske Hall. The view looks northeast from Claremont Avenue at the line of West 118th Street in 1903.

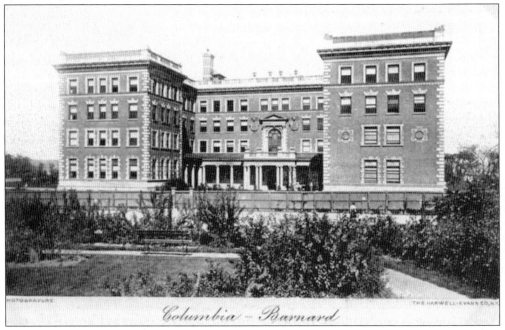

Just a few years after the purchase of the additional land below West 119th Street, there is a thriving garden with pathways, benches, and tennis courts laid out before Milbank Hall. The fence that enclosed the new campus screens the view from West 119th Street, which was open to traffic until 1952.

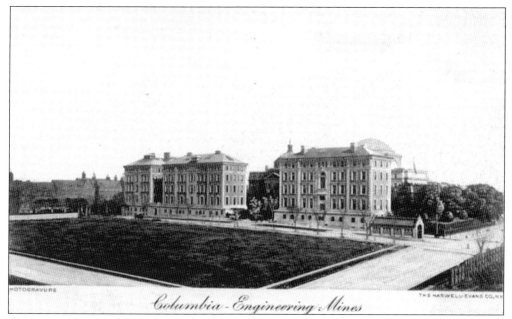

Columbia - Engineering - Mines

This magnificent view is from Claremont Avenue at West 116th Street looking northeast toward Columbia's campus in 1904. In the foreground is Barnard's new campus, the Milbank Quadrangle, four years before its first building, Brooks Hall, was constructed. The new subway entrance lies in the middle of Broadway at West 116th Street, where it serviced generations of students, employees, and residents until the mid-1960s.

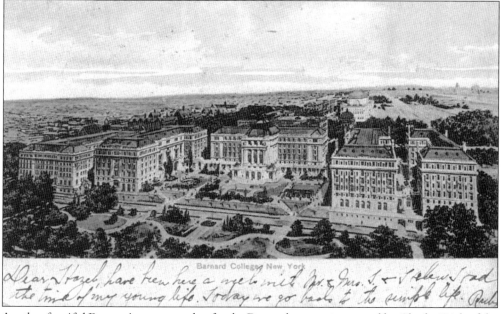

A rather fanciful Beaux-Arts master plan for the Barnard campus, prepared by Charles Rich of the architectural firm Lamb and Rich, lifts the campus above street level and gives it a monumental view over the Hudson River. A major problem with this design was that it presumed the land along Claremont Avenue and Riverside Drive could be turned into parkland when residential development was imminent.

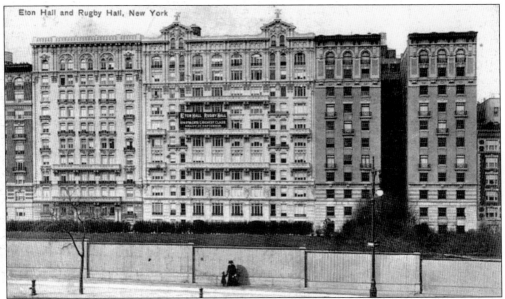

"Apartments of the Highest Class" was how architect Gaetan Ajello's Eton and Rugby Halls were advertised in 1910, as they joined their high-class neighbors Peter Minuit (built in 1909 and designed by Ajello) to the left and Campus (built in 1910 and designed by Schwartz and Gross) to the right. The view is from Broadway looking west across the Barnard campus to Claremont Avenue at the line of West 117th Street. To the far right is the diminutive Malvern (built in 1906 and designed by George F. Pelham), now the dormitory referred to as 47 Claremont.

The first building on the Milbank Quadrangle, the dormitory Brooks Hall, was built in 1908 as a memorial to Rev. Arthur Brooks, who was the first chairman of Barnard's board of trustees. This view shows the main facade from the campus; the rear facade of the building faces West 116th Street.

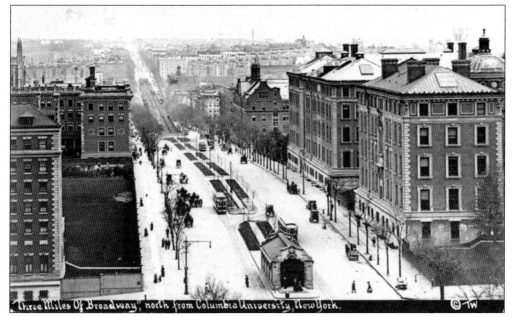

Titled "Three Miles of Broadway," this Thaddeus Wilkerson photograph looks over Morningside Heights toward Manhattanville from West 116th Street in 1909. With its first dormitory building seen here on the left, Barnard College was still primarily a commuter school and would remain so for most of the century. It would take another eight years for a building to be erected on the Barnard campus.

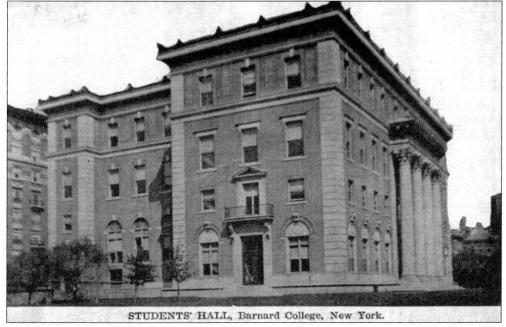

Student's Hall (now Barnard Hall), the gift of Jacob Henry Schiff, was completed in 1917. This view looks at the south and main entrances from Brooks Hall. It housed the gymnasium, swimming pool, and dance studios on its lower levels; the upper floors contained alumni offices, study rooms, lounges, a student cafeteria, the faculty dining room, and the Ella Weed Library.

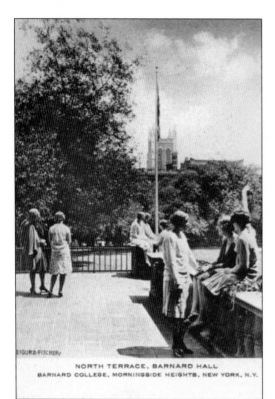

NORTH TERRACE, BARNARD HALL
BARNARD COLLEGE, MORNINGSIDE HEIGHTS, NEW YORK, N.Y.

Barnard College is captured beautifully in these two images taken by the Danish-born architectural photographer Sigurd Fischer in the 1920s. The self-confidence of this small liberal arts college in the big city is evident in his depictions of social and athletic life on campus.

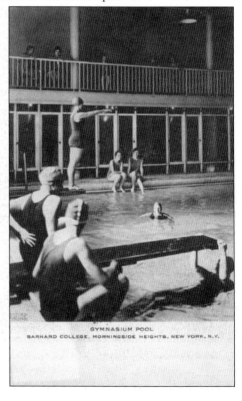

GYMNASIUM POOL
BARNARD COLLEGE, MORNINGSIDE HEIGHTS, NEW YORK, N.Y.

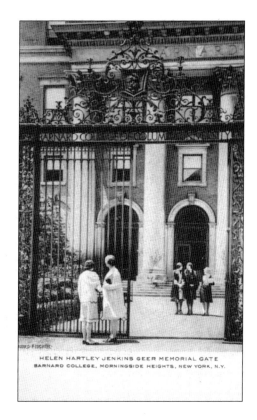

HELEN HARTLEY JENKINS GEER MEMORIAL GATE
BARNARD COLLEGE, MORNINGSIDE HEIGHTS, NEW YORK, N.Y.

Prominently featured is Barnard Hall, a great contribution to the identity of the college. Also invaluable was a monumental entryway, the Geer Memorial Gate, which Barnard received in 1921 as a gift in memory of Helen Hartley Jenkins Geer, class of 1915. These images were also taken by Fischer.

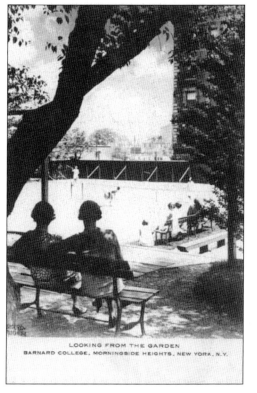

LOOKING FROM THE GARDEN
BARNARD COLLEGE, MORNINGSIDE HEIGHTS, NEW YORK, N.Y.

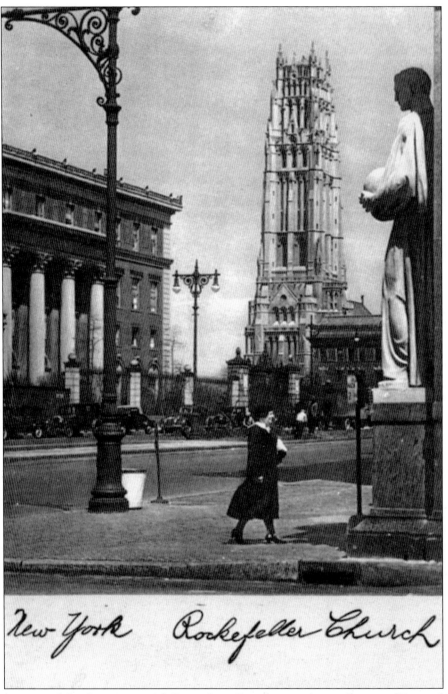

New York Rockefeller Church

The expanse of the Geer Memorial Gates along Broadway and prominence of Barnard Hall become secondary as one's eye is drawn to the tower of the Riverside Church in this view from the Columbia gates at Broadway and West 116th Street in the 1930s. Referred to here as Rockefeller Church in recognition of its donor John D. Rockefeller Jr., it was built from a design by the firm Allen and Collens along with Henry C. Pelton between 1926 and 1930.

Five

LOWER MORNINGSIDE HEIGHTS
WEST 106TH TO WEST 110TH STREETS

The high rocky plateau overlooking the Hudson River above West 110th Street had many names in the two centuries before Columbia settled there. Called Harlem Heights, or Vandewater Heights after 18th-century landowners, it was sometimes referred to as Bloomingdale, from the Dutch *Bloemendaal*, or Riverside Heights. Morningside Heights, a reference to the park on its eastern edge, caught on in the 1890s as Columbia University and the Cathedral Church of St. John the Divine began buying land here, although the name Cathedral Heights was eminently preferred by the latter institution. Although the rocky plateau begins its rise at West 110th Street and continues to West 122nd Street, this book expands the area to encompass some beautiful residences, structures, and institutions on the southern fringes of the neighborhood.

From West 106th to West 110th Streets, one finds the first women's hospital in the country, elegant apartment houses along Broadway and Riverside Drive, and Schuyler Square, the triangle formed by the intersection of Broadway and West End Avenue. The latter is now occupied by a lovely park and memorial to Isadore and Ida Straus, owners of R. H. Macy and Company and partners in Abraham and Straus department stores, who lived nearby and died on the RMS *Titanic*.

The grand apartment houses began arriving along Riverside Drive as real estate values made it lucrative to redevelop estates and mansions and build private residences on top of one another. Not everyone was happy with the development along Riverside Drive. A Mrs. Rutherford (her first name was not printed in the *New York Times* article at the time) owned a mansion on the corner of West 108th Street. In 1905, the lot immediately to the north was developed as the Bonavista (see page 70). Taking matters into her own hands, she erected a 36-foot-high brick "spite wall" to obscure the first three floors of the Bonavista's southern exposure. Alas, her mansion also succumbed to the developers in 1917. But the new building, a few stories higher than the Bonavista, blocked all of its remaining southern windows. The new building's name was the Rutherford.

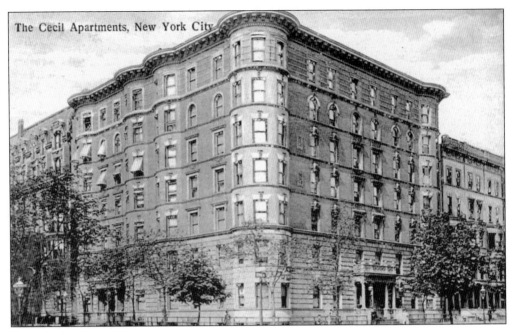

The Cecil Apartments, New York City.

This delightful building looks much the same today as it did in this 1915 view. The sensitive addition of fire escapes a few years later is the most notable change to the facade. It comprises two apartment houses: the Cecil, which has its entrance on West End Avenue, and the Van Horne, which is on West 106th Street. In 1899, apartments rented for $1,400 per year. (Collection of Bob Stonehill.)

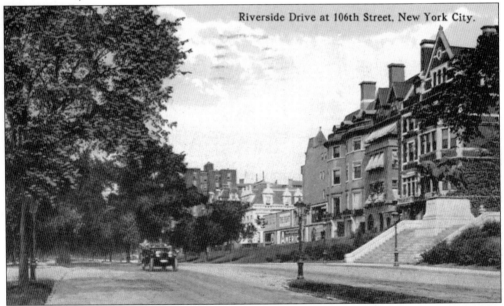

Riverside Drive at 106th Street, New York City.

The last hurrah for most of the mansions and townhouses on Riverside Drive was during the latter part of the second decade of the 20th century, when this image of Riverside Drive at West 106th Street was published. Within five years, the three townhouses on the right would be demolished for a banal apartment house. However, the freestanding mansion and sumptuous townhouses north of West 107th Street still stand today.

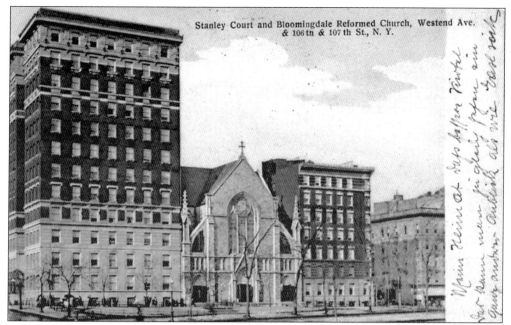

Stanley Court (built in 1906) stands at West 106th Street and West End Avenue while the Waumbek (built around 1900) occupies the corner of West 107th Street. In between them is the sixth location of the Bloomingdale Reformed Church, dissolved in 1913 when the apartment house at 949 West End Avenue (originally named the San Domingo) was built. In the foreground is Schuyler Square.

The Manchester stands majestically on the northeast corner of Broadway and West 108th Street. Built from 1909 to 1910 by architects Neville and Bagge as a modern fireproof building of the highest class, it boasted genuine mahogany doors, seven-foot-high wainscoting, and exposed ceiling beams of quartered English oak. The building across the street still stands and, until recently, housed Cannon's Pub. (Collection of Bob Stonehill.)

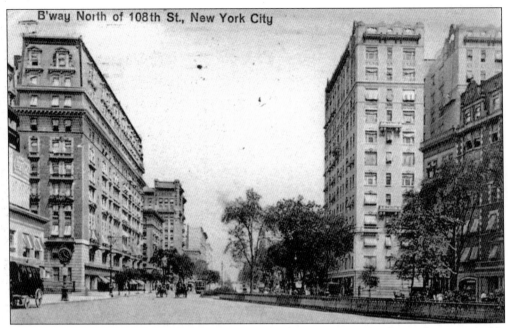

This view looking north up Broadway at West 108th Street in 1914 is instantly recognizable today, since the grand apartment houses, the Manchester on the right, and the Manhassett on the left, still dominate the view. The image was taken where West End Avenue ends at West 107th Street.

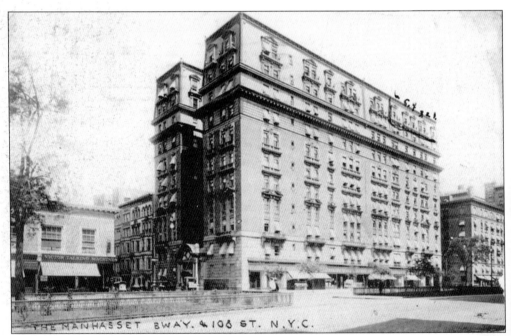

THE MANHASSET BWAY. & 108 ST. N.Y.C.

The Manhassett was built in 1904 by architects Janes and Leo just as the subway arrived at West 110th Street. The 11-story building sits on a lot 100 by 200 feet stretching from West 108th to West 109th Street and originally had six apartments per floor with either six, seven, or nine rooms. Rents in 1908 ranged from $1,800 to $3,500 annually. (Collection of Bob Stonehill.)

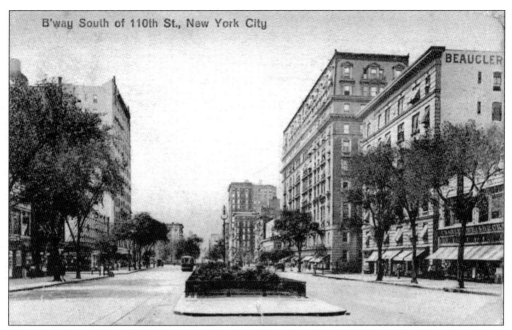

The view from West 110th Street south along Broadway in 1914 shows the Beauclere (built around 1900) on the right, which lasted only three decades before being razed for a one-story commercial building housing a Woolworth's from 1936 to 1997.

A flurry of construction activity engulfed Cathedral Parkway (West 110th Street) between Broadway and Amsterdam Avenue in the first decade of the 20th century, with no fewer than seven apartment houses completed in 1908 and 1909. The Brittania, St. Albans, Dartmouth, and Morris (or Parkway) Hall are on the left side of the street; Irving Court, Amherst, and Cortlandt are on the right side. The Mark Anthony and Prince Humbert, on the far right, followed in 1911. (Collection of Bob Stonehill.)

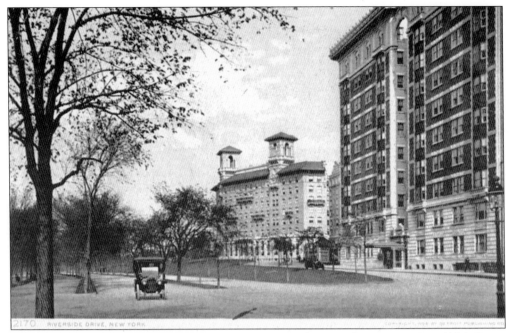

The Bonavista (built in 1905) at the northwest corner of Riverside Drive at West 109th Street is on the right, with the "spite wall," described on page 65, just out of view. Its advertising claimed that its four apartments per floor had 8, 9, or 12 rooms with excellent light and air, and "afforded all the privacy and exclusiveness of a private residence."

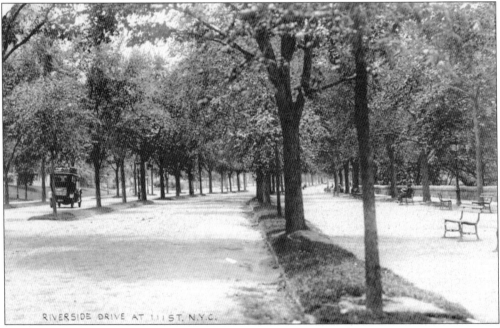

Riverside Drive was an integral part of Riverside Park as designed by Frederick Law Olmsted in 1873, and can be seen in this view looking south from West 111th Street. The landscaped gardens, lush trees, and quiet setting were all inherited from the private estates that existed along the picturesque banks of the Hudson River.

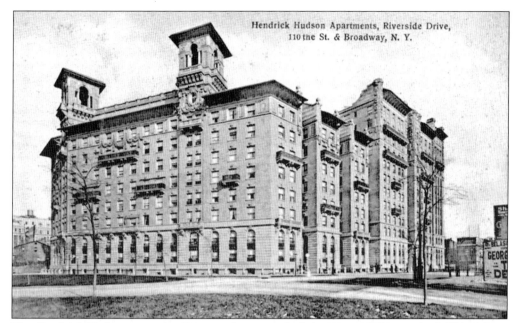

The Hendrick Hudson, a massive Tuscan palazzo, was built in 1906 and 1907 on the full blockfront of Riverside Drive between West 110th and West 111th Streets from a design by Rouse and Sloan. This allowed great views of the drive, the park, and the river below. The square towers at the roofline were briefly connected by an open trelliswork arbor, already removed in this 1910 view, an augur of things to come.

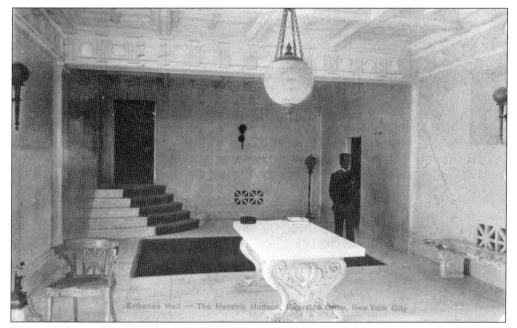

The grandeur of the Hendrick Hudson's design may be seen in the interior as well. This marble-clad entrance hall is on West 110th Street, not far from Riverside Drive, and has deep coffered ceilings and bronze lamp fixtures. The on-site amenities, for the use of tenants and guests only, included a billiard parlor, café, barbershop, and women's hairdressing salon.

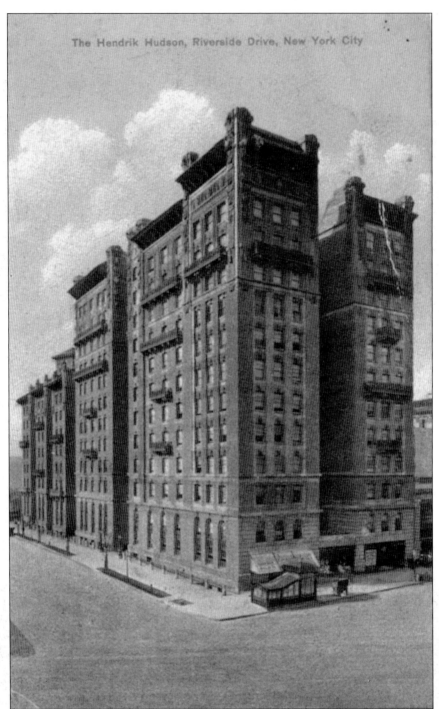

The Hendrik Hudson, Riverside Drive, New York City

On the northwest corner of Broadway and West 110th Street is the 12-story annex to the Hendrick Hudson built even as the original building was first being occupied in 1907. It is now known as College Residence after many years as a single-room occupancy hotel. Maybe it is just a trick of perspective, but the eight-story Hendrick Hudson seems to shrink in the background compared to its neighbor on the more populous thoroughfare.

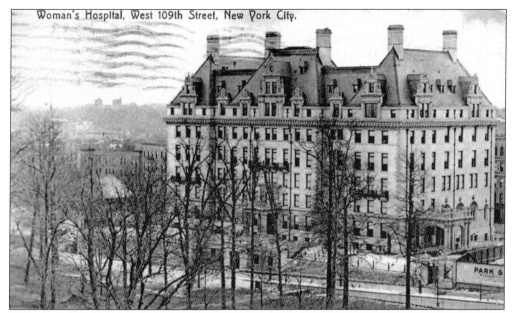

Founded in 1856 as the first hospital focusing on the needs of women in the United States, Woman's Hospital moved to Morningside Heights in 1906 between Amsterdam and Ninth, or Columbus, Avenues. Contrary to the label on the postcard, its north facade, seen here, overlooked the grounds of the Cathedral Church of St. John the Divine at West 110th Street, where building had begun 14 years earlier.

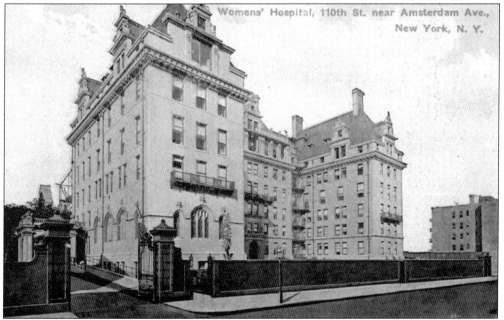

The southern facade of the hospital building shows architects Allen and Collens' intention of maximizing southern light by creating a courtyard on the West 109th Street side (incorrectly labeled on the image above). Woman's Hospital was absorbed by St. Luke's Hospital in 1952 but remained in this building and two additions until 1968. It was demolished at that time for the Cathedral Parkway Houses.

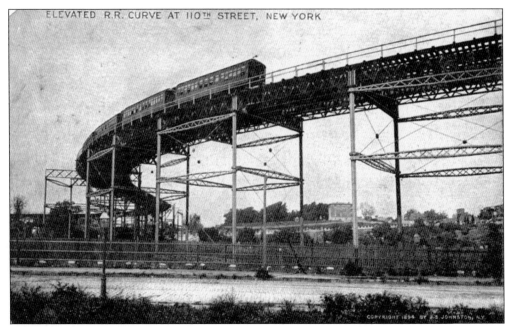

The Ninth Avenue Elevated line of the Manhattan Railway Company was the quickest way to get to Morningside Heights at the end of the 19th century. But due to the rocky elevation of the neighborhood, the line skirted around the heights in this S curve, an engineering marvel of its day. This view looks west from Eighth Avenue toward Morningside Park in 1894.

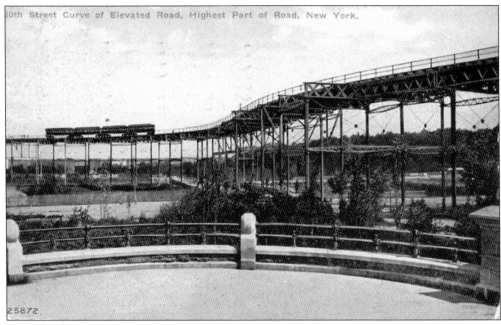

Looking east from Morningside Park around 1900, it is noticeable that there is no station at West 110th Street at this time. The stations closest to Morningside Heights were at West 104th Street and Ninth Avenue and West 116th Street and Eighth Avenue, now Frederick Douglass Boulevard. Central Park lies beyond the elevated.

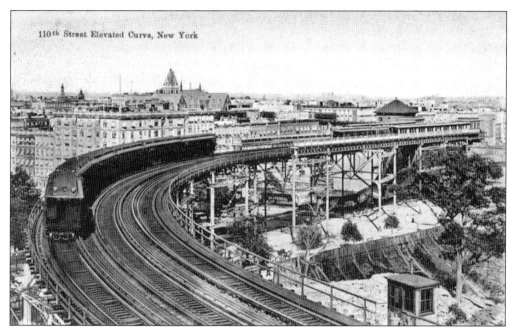

110th Street Elevated Curve, New York

Having caught the popular imagination—what a thrill ride it must have been—many postcards exist of this extraordinary structure. *King's Handbook of 1892* describes it as "the crowded junction points of lines, the stations in mid-air, the swallow-flight of the light trains, command admiring wonder . . . one of the most audacious of engineering feats."

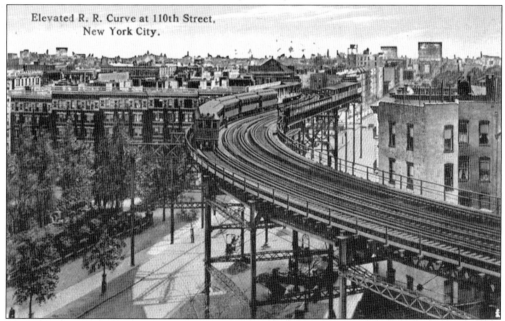

Elevated R. R. Curve at 110th Street,
New York City.

Before reaching the point depicted here, the elevated traveled from South Ferry along Ninth Avenue from West 14th Street to West 110th Street. Here the tracks turn east to enter the West 110th Street station. The view is northeast toward the burgeoning neighborhood of Harlem. The building to the far right is extant and still bears the irregular eastern facade necessitated to accommodate the elevated structure.

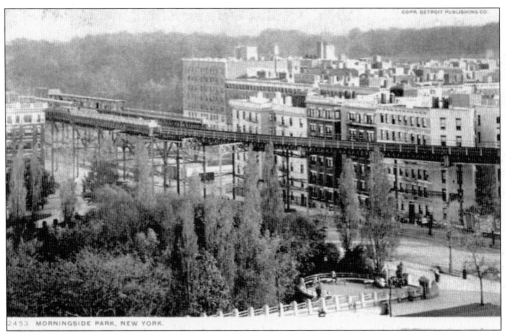

Looking southeast over Morningside Park toward Central Park around 1906 one sees a neighborhood of moderate apartment houses beyond the elevated along West 110th Street where there were none just a decade earlier. The intersection at the center is Manhattan Avenue.

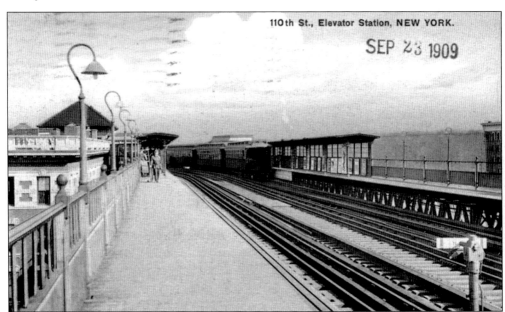

The West 110th Street elevated station was built in 1903 to accommodate the growing population of Morningside Heights and environs. A workman is on the platform with a ladder presumably to change the lightbulbs. The triangle-roofed structure to the left housed four elevators used to bring passengers to street level from this, the highest elevated structure in the city at over 100 feet. The view looks east as an uptown train pulls out of the station on its way to the West 116th Street station.

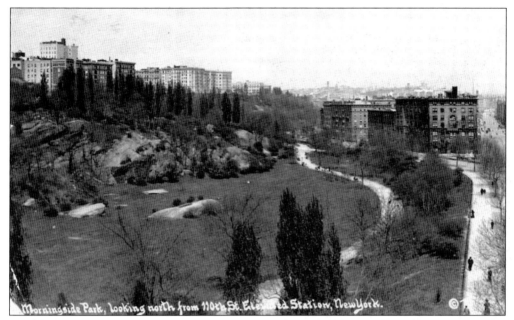

Morningside Park, looking north from 110th St. Elevated Station, New York.

Could that man with the ladder be the photographer Thaddeus Wilkerson, who took this stunning view of Morningside Park at about the same time the prior postcard was postmarked in 1909? Taken from the north platform of the station, the apartments of Morningside Drive are on the heights at left, while the plains of Harlem stretch out along Morningside and Manhattan Avenues at right.

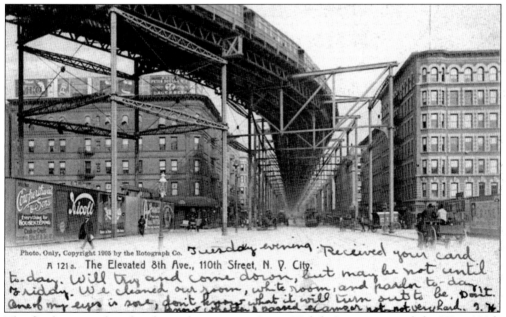

Photo. Only, Copyright 1905 by the Rotograph Co.
A 121a. The Elevated 8th Ave., 110th Street, N. Y. City.

The final curve takes the elevated uptown train up Eighth Avenue toward the West 116th Street station. It would continue along this straight route to its terminus at 155th Street and the Harlem River. The Ninth Avenue Elevated, considered redundant due to the construction of the Interborough Rapid Transit (IRT) and the Independent (IND) subway lines, was dismantled in 1940.

LIGHT ON THE PAST.

The Hudson–Fulton Celebration of 1909 commemorated the 300th anniversary of the discovery of the Hudson River by Henry Hudson and 100th anniversary of the inauguration of steam navigation by Robert Fulton. From September 25 to October 9 of that year, festivities were held all over the city, including carnivals, historical parades, illuminations, military parades, and a naval parade on the Hudson River opposite Riverside Park.

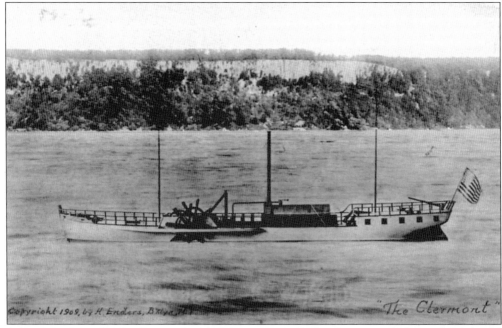

"The Clermont"

A reproduction of Fulton's steamboat *Clermont* was built for the centennial. In addition, the people of Holland presented a full-scale replica of the *Half Moon*, the ship in which Hudson made his voyage in 1609. Both ships made visits to the towns and villages along the Hudson in the weeks following the opening events. (Collection of Bob Stonehill.)

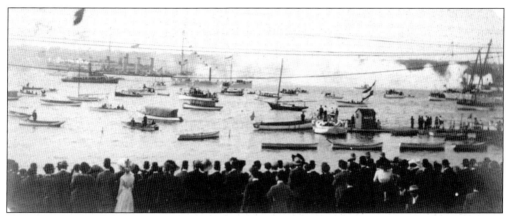

The celebration opened with the Naval, or Water, Parade on September 25, 1909, which included an impressive array of 53 ships of the United States—battleships, cruisers, torpedo boats, and submarines—as well as an international fleet of over 20 ships. Here the *Clermont*, slightly left of center with a flag on each mast, is being saluted at Riverside Park and West 110th Street.

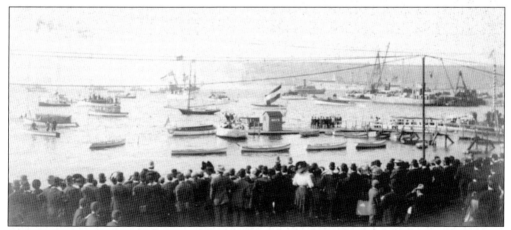

In this photograph from the same vantage point, the *Half Moon* is being saluted. It is the ship with flags flying from each of its masts. Most of the vessels in the foreground are pleasure craft. The numerous spectators lining the river had been there for many hours enjoying the glorious weather; most had crowded onto the subway and alighted at West 110th Street and Broadway.

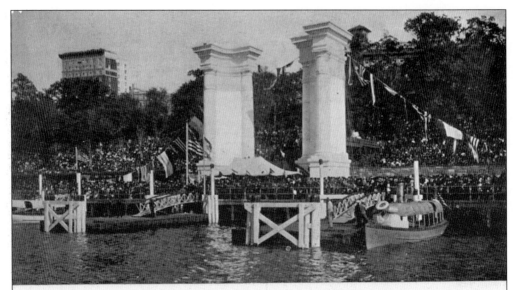

The Morningside Heights area was given the great honor of hosting the official landing and reviewing stand at West 110th Street and Riverside Park. These monumental but temporary structures were built for the occasion. The roof towers of the Hendrick Hudson apartments are visible through the trees at right. The building to the left is the Strathmore at 404 Riverside Drive.

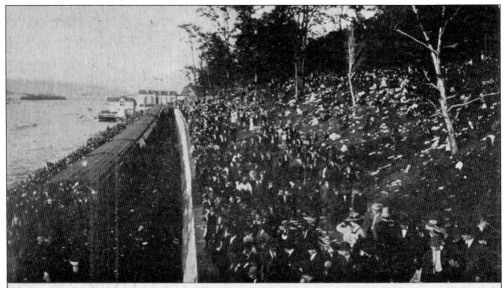

42 A view of the enormous crowds near Grant's Tomb reviewing the Water Parade
September 25th, 1909, "Hudson Fulton" Celebration

Looking north from the reviewing stand toward the ferry piers of Manhattanville, one sees the massive crowds, and the refuse that they left behind in the park. The canopy for protection from the elements barely covers the crowds gathered on the tracks of the New York Central Railroad along the riverfront.

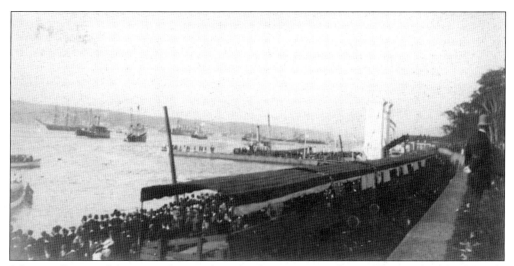

A better glimpse of the reviewing stands under the canopy can be seen here as the Naval Parade proceeds by the *Half Moon*, to the left of the central landing, late in the afternoon. The parade was repeated, with illuminations, that same evening beginning at 7:00.

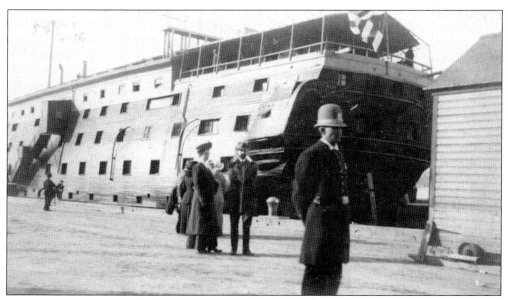

Built as the *Alabama* and ready for launch in 1825, this ship was renamed the *New Hampshire*, launched and commissioned in 1864 and used primarily as a store and depot ship. By the time of the Hudson–Fulton Celebration in 1909, she had been renamed the *Granite State* and was stationed in the Hudson River as a training ship. The *Granite State* caught fire and sank in 1921.

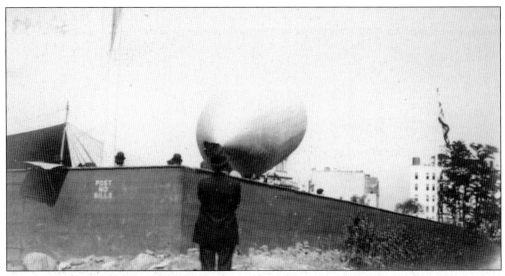

George Tomlinson (1876–1936), a pioneering aviator, was one of several competitors in the race for the Pulitzer Prize, a publicity stunt sponsored by the *New York World* to award $10,000 to the first flight of any kind to reach Albany from New York. His dirigible was housed in a shed on Claremont Avenue at West 119th Street until September 30, 1909, when conditions were favorable for flight.

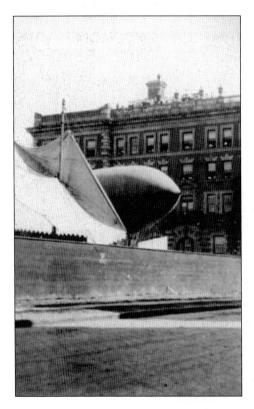

Spectators peer from every window and gaze from the rooftop of Fiske Hall (part of Milbank Hall) on Claremont Avenue between West 119th and West 120th Streets. Tomlinson's airship was 90 feet long and propelled by four Curtiss engines. At 11:36 in the morning, the balloon was released and immediately rose to 300 feet.

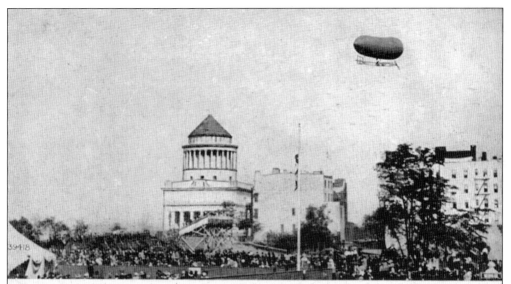

The Geo. L. Tomlinson dirigible Airship in trial flight, September 30, 1909, over Grant's Tomb during the Hudson-Fulton Celebration at New York.

The dirigible continued its rise over Union Theological Seminary and Grant's Tomb and ascended to over 1,000 feet by the time it left Morningside Heights. Tomlinson made it as far as White Plains, where he touched down safely after his gas tank started leaking, at 1:30 in the afternoon. Although Wilbur Wright and others took up the challenge, it was more than a year before aviator Glenn Curtiss would collect the prize. (Collection of Bob Stonehill.)

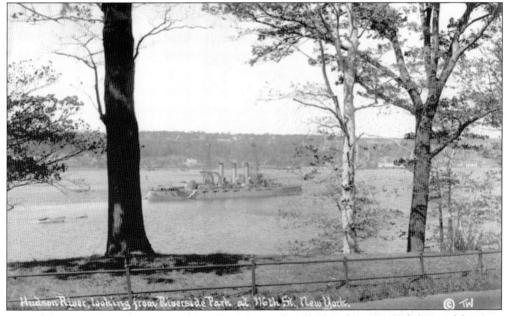

One of the many United States warships along the Hudson during the two-week-long celebration, this one is positioned off West 116th Street. Riverside Park had not yet entered its second phase of development under Robert Moses in which the railroad was covered over and the Henry Hudson Parkway built along the waterfront in 1937.

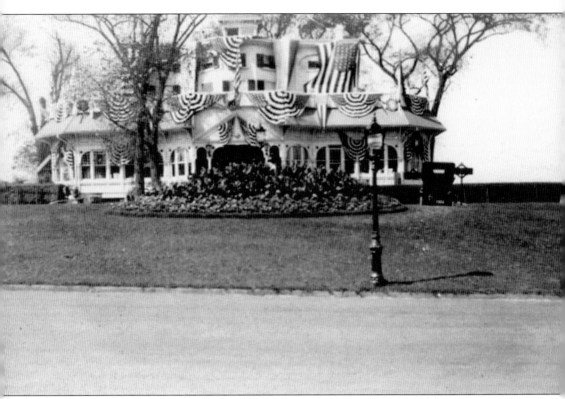

Bunting adorns the Claremont Inn for the duration of the celebration. Built as a country home in 1804, it was located on the grounds north of Grant's Tomb and south of the Riverside Drive viaduct until 1951. The Claremont Inn will be discussed further in chapter 7.

Six

THE HEART OF
MORNINGSIDE HEIGHTS
WEST 110TH TO WEST 120TH STREETS

Expansion of the university and the development of Morningside Heights accelerated greatly after 1900 with the arrival of the IRT subway line in 1904. A few years prior, speculative developers began building middle-and upper-class apartment houses along the major thoroughfares. Andrew Dolkart, in *Morningside Heights: A History of Its Architecture and Development*, finds that the principal developers in the neighborhood were the Paterno brothers, who built 37 apartment buildings on the heights ranging from modest to the grandiose; the latter including buildings such as the Rexor, Luxor, and Regnor on the west side of Broadway from West 115th to West 116th Streets. Developers, such as the Paternos, would hire architects specializing in apartment design but who, with rare exception, were not trained at prestigious schools and did not work for major firms. Some of the most prolific firms appearing again and again in these chapters are Schwartz and Gross, Neville and Bagge, and George F. Pelham. According to Dolkart, together these three firms were responsible for the design of more than half of the apartment houses on Morningside Heights.

Proximity to the subway and Riverside Park were important in determining the size and character of the residences erected. Riverside Drive and Broadway were at the top of the hierarchy of streets, and large, elegant, high-class buildings flourished here during the early decades of the 20th century. Cathedral Parkway (West 110th Street), West 116th Street, and lower Claremont Avenue were slightly lower in stature. Amsterdam Avenue, Morningside Drive, and the side streets were for the less affluent. While examining the changing streetscapes of Broadway, Claremont Avenue, and Amsterdam Avenue, this chapter will also focus on the pioneering institutions of the Cathedral Church of St. John the Divine and St. Luke's Hospital.

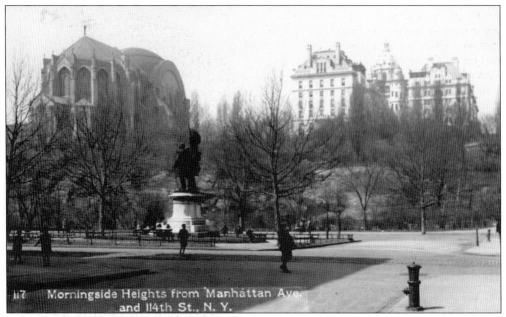

This spectacular view of Morningside Heights from Manhattan Avenue at West 114th Street in Harlem shows the rugged cliffs of Morningside Park around 1915 and two of the pioneering institutions on the heights, the Cathedral Church of St. John the Divine and St. Luke's Hospital. The statue in the foreground of Lafayette and Washington was sculpted in 1900 by Frederic-Auguste Bartholdi.

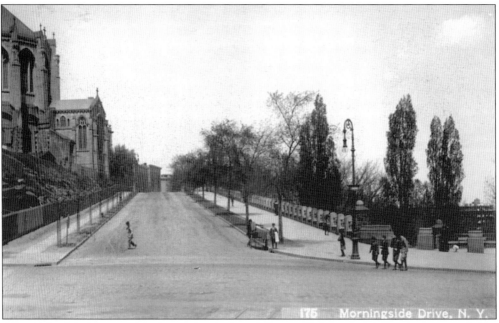

Morningside Park extends from 110th Street to 123rd Street and occupies almost 30 acres of land deemed unsuitable for development. Looking north on Morningside Drive from West 110th Street, one sees the street-level ornamentation of the buttressing masonry wall designed by Jacob Wrey Mould and constructed by 1886.

Frederick Law Olmsted (1822–1903) was America's leading landscape architect of the late 19th century. His designs for Central Park and Prospect Park, in collaboration with Calvert Vaux, are among his most notable achievements. Although his designs for Morningside Park were initially rejected, he and Vaux were hired to continue landscape enhancements to the park in 1887 after the death of Jacob Wrey Mould.

FREDERICK LAW OLMSTED, LL.D.

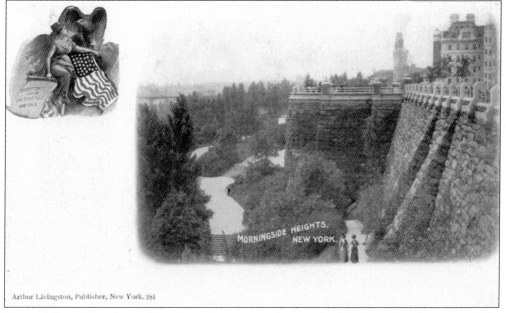

MORNINGSIDE HEIGHTS, NEW YORK.

Arthur Livingston, Publisher, New York. 281

The melding of the plans of the three designers can be seen in this view taken from one of the semioctagonal bays overlooking the park at West 117th Street. The imposing buttressed wall is seen to the right and center towering over the ladies taking a stroll on the meandering paths down through the park. A wider, straighter walkway steps down to the Harlem plains.

This monumental staircase links the park with Morningside Heights at West 116th Street. This stairway was so heavily traveled during the early years of the 20th century, as this was the fastest way to get to Morningside Heights from the elevated station at Eighth Avenue, that several proposals for an elevator at this location were entertained.

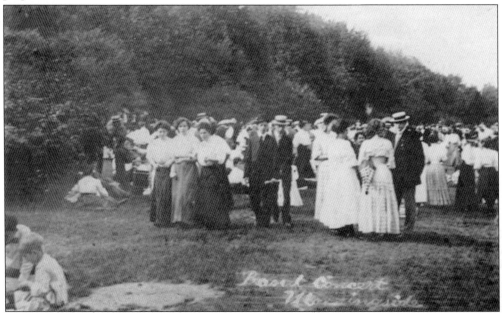

Although recent generations of Columbians have been warned not to walk through Morningside Park, this has not always been the case, as evidenced by this group of revelers enjoying a band concert in the park in 1907. Nor is it the case today. After an extensive refurbishment program, which included installing new playgrounds and creating a picnic area and an ornamental pond and waterfall in the early 1990s, the park is once again thriving. (Collection of Bob Stonehill.)

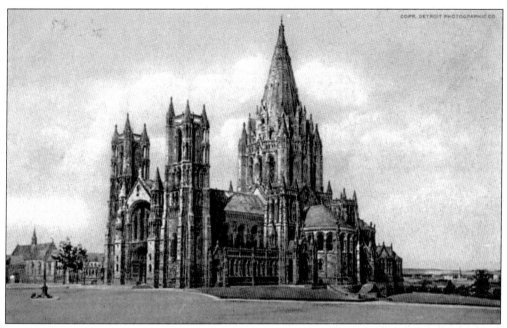

This perspective shows the original 1890 Heins and LaFarge design for the Cathedral Church of St. John the Divine, the seat of the bishop of the Episcopal Church in New York. The cathedral entrance is located at West 112th Street and Amsterdam Avenue on a plot of land purchased in 1887 that stretches from West 110th to West 113th Streets between Morningside Drive and Amsterdam Avenue.

Rt. Rev. Henry Codman Potter (1835–1908), bishop of the Protestant Episcopal Diocese of New York from 1888, continued the work of his uncle, Rt. Rev. Horatio Potter, who obtained the charter for the cathedral in 1873. The second Reverend Potter was responsible for commissioning the plans, raising the $850,000 needed for the purchase of the land, and beginning the first phase of development.

RT. REV. HENRY C. POTTER, D.D., LL.D.

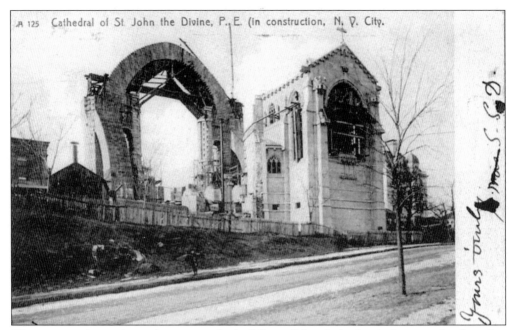

The east crossing arch can be seen as the building of the choir above the crypt is advancing around 1904, 12 years after the cornerstone was laid in 1892. The choir was completed eight years later in 1911. The chapel at the right, the Belmont Chapel, now St. Saviour's, is the first of seven chapels radiating from the choir that represent the city's ethnic diversity.

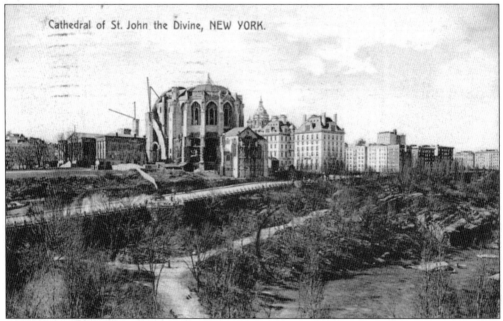

In 1910, the choir appears to be nearing completion while the remaining arches of the crossing are begun. The view looks northwest toward the heights from the elevated structure at West 110th Street. The Leake and Watts Orphan Asylum building is to the left and predates the building of the cathedral.

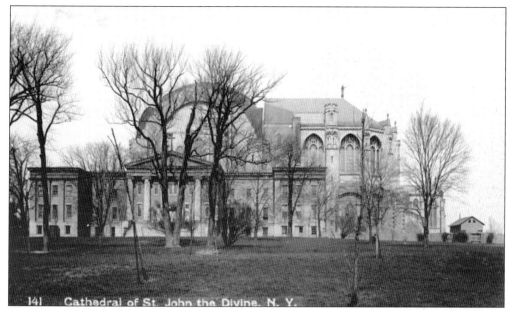

141 Cathedral of St. John the Divine. N. Y.

This view north toward the cathedral from West 110th Street around 1910 places in the foreground the former home of the Leake and Watts Orphan Asylum. Attributed to architect Ithiel Town, this building was first occupied in 1843 and abandoned in 1891 for a new home in Westchester. A portion of the building still stands, presenting a rather troublesome dilemma for when the south transept of the cathedral is ready to be built.

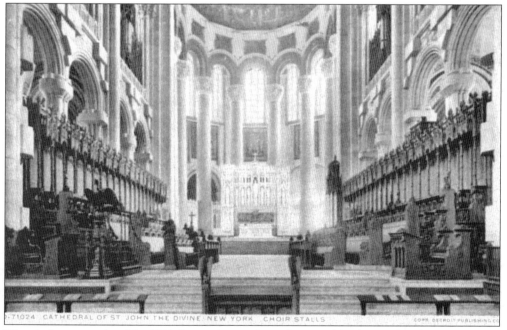

The choir as completed in 1911 featured a soaring white marble altar and eight monumental columns of gray granite 55 feet high and weighing 130 tons each. The columns were quarried in Vinalhaven, Maine, transferred on a barge to West 134th Street and the Hudson River, and carted down Amsterdam Avenue to the cathedral.

91

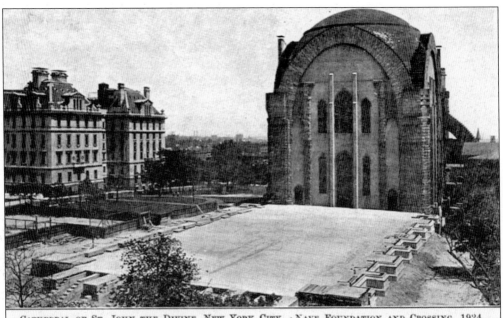

CATHEDRAL OF ST. JOHN THE DIVINE, NEW YORK CITY. NAVE FOUNDATION AND CROSSING, 1924.

The four arches of the crossing have been temporarily covered and walled awaiting further building in this view from about 1920. In 1911, the choir, two chapels, and the crossing were consecrated, the latter holding almost 2,000 congregants. The foundation for the nave was laid in 1916, but World War I intervened and it was not until the mid-1920s that construction began. It would not be until 1941 that the nave and west facade would be dedicated.

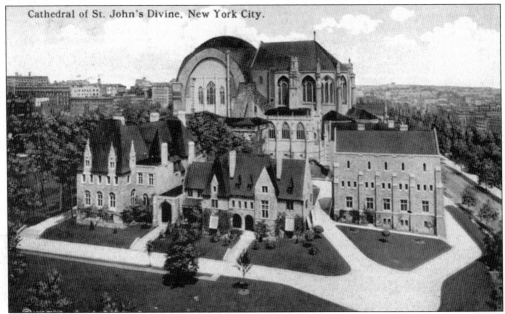

Cathedral of St. John's Divine, New York City.

The ancillary buildings to the cathedral as seen from West 110th Street include, from left to right, the Bishop's House and Deanery (built from 1912 to 1914 by Cram, Goodhue, and Ferguson) and the Cathedral School (built in 1912 and 1913 by Cook and Welch). The latter was originally built for the Choir School, a day school for boys.

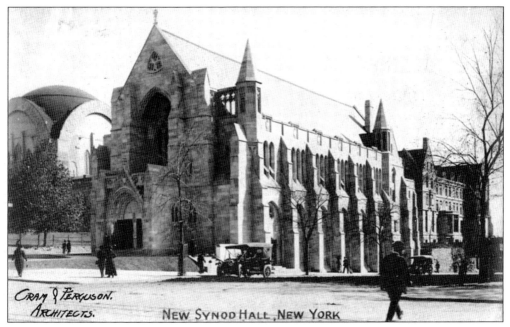

Cram, Goodhue and Ferguson also designed the Synod House (built between 1911 and 1913) on the northeast corner of Amsterdam Avenue and West 110th Street. With its timber roof and grisaille-glass windows, Synod House was originally built for the 1913 General Convention of Episcopal Church. The oldest of the ancillary buildings, St. Faith's House (built in 1909 and 1910 by Heins and LaFarge), now Diocesan House, is to the right.

Architectural tastes change, and architects sometimes do not live long enough to see their designs come to fruition, especially when working on a cathedral. The Episcopal church was ready for a change once the choir was finished. This is one of at least six different designs by Ralph Adams Cram, the architect chosen as replacement to replace Heins and LaFarge.

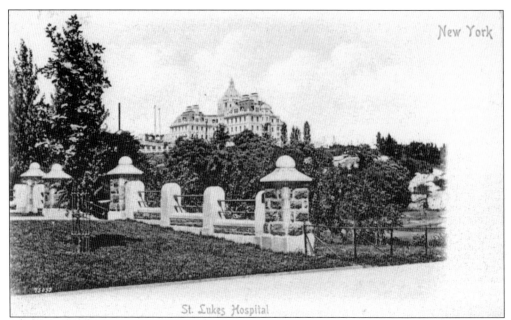

St. Lukes Hospital

St Luke's Hospital, established in 1850 by the Episcopal Church, moved up to Morningside Heights after buying the entire block to the north of the cathedral in 1892. Ernest Flagg was chosen as the architect and the first pavilions were built between 1892 and 1896. The sight of a great cathedral rising right across the street must have been an inspiration to the patients and staff.

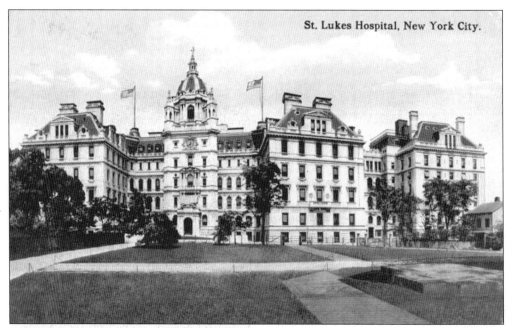

St. Lukes Hospital, New York City.

The first pavilions along West 113th Street, from left to right, are Norrie Pavilion, the administration building with its elaborate dome containing an operating theater, and the Minturn Pavilion. The pavilion to the right was built later, between 1903 and 1906. Known as the Margaret J. Plant Pavilion, it incorporated iron balconies into its east facade over Morningside Park.

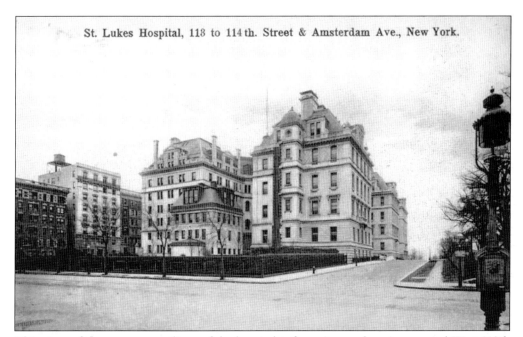

St. Lukes Hospital, 113 to 114th. Street & Amsterdam Ave., New York.

This view of the western pavilions of the hospital is from Amsterdam Avenue and West 113th Street. The Vanderbilt Pavilion (left) and the Norrie Pavilion dwarf the pathology building (built between 1892 and 1896). All three structures were demolished in the 1950s for subsequent expansion of the hospital along Amsterdam Avenue.

114TH ST. WEST FROM AMSTERDAM AVE. N.Y. CITY. 187

In 1912, the southwest corner of Amsterdam Avenue and West 114th Street was the province of the mid-size apartment house. The 1906 corner building by Stern and Morris was demolished in 1968 for 1090 Amsterdam Avenue, whose ground floor now houses the restaurant Strokos. The buildings directly behind it are still extant. The Tennessee (now Ruggles Hall), the Arizona, and the San Maria were all built by Schwartz and Gross in 1908. (Collection of Bob Stonehill.)

The Rockfall, built in 1909 and designed by George and Edward Blum, is located on the northeast corner of West 111th Street. The Devonshire (built in 1907), with its air of British sophistication, was designed by Neville and Bagge and is located on the southeast corner of West 112th Street. (Collection of Bob Stonehill.)

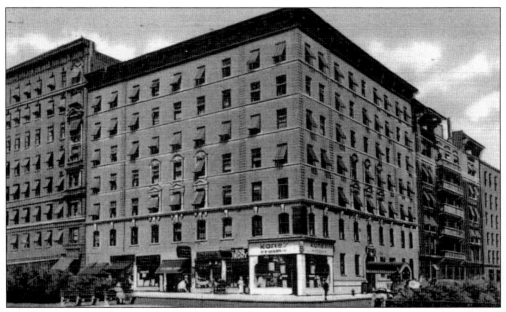

The Ostend, located at the northeast corner of West 112th Street and designed by Neville and Bagge, was an earlier speculative venture erected in 1900, four years before the subway arrived. Until the neighborhood proved itself viable for development, buildings were smaller and less ornamented than their later neighbors. Shown here in the mid-1940s as the Oxford Hotel, this corner has become world famous as the site of Tom's Restaurant, the diner used in the establishing shot for the television show *Seinfeld*.

The Mill Luncheonette, a venerable Columbia institution, made its home in the storefronts on the ground floor of the Allerton on the southwest corner of Broadway and West 113th Street. Designed by Neville and Bagge and completed in 1910, this luxury building boasted large, well-planned suites with ample accommodation for servants. (Collection of Bob Stonehill.)

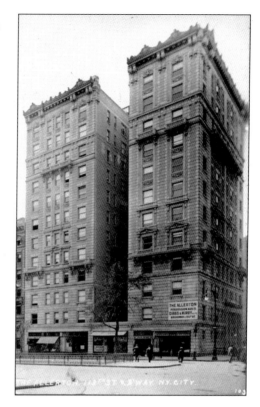

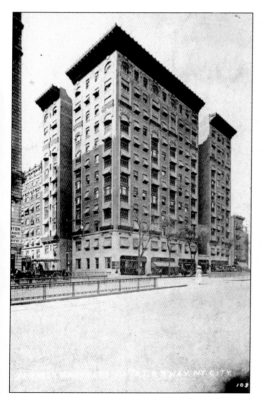

Another magnificent work by George and Edward Blum is Forest Chambers, built in 1909 along most of the frontage from West 113th to West 114th Streets on the west side of Broadway. Forest Chambers has been home to Mondel's Chocolate since 1943 and to the West End Bar until 2006. (Collection of Bob Stonehill.)

BROADWAY PRESBYTERIAN CHURCH
N.W. COR 114TH ST. & B'WAY. N.Y.C. 2493

The Broadway Presbyterian Church on the northwest corner of Broadway and West 114th Street is nearing completion in 1912. This is the third home of the church, first organized in 1825. The sign on the base of the tower states that services will be held each Sunday at Earl Hall on Columbia's campus until the building is finished. An enthusiastic parishioner writes (on verso), "Hope to get a photo of the inside sometime. It is very rich and beautiful. The Sunday School has increased from 35 to 260 in the last four weeks. Next Sunday the Church will take in nearly one hundred new members."

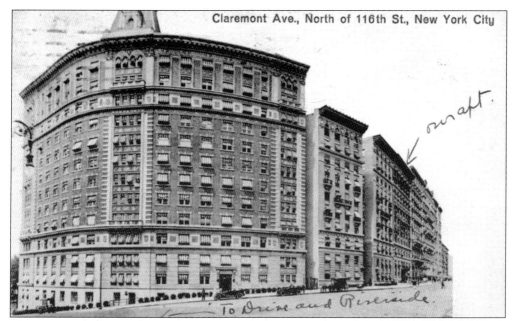

The curving facade of the Paterno (built in 1909 by Schwartz and Gross) is the perfect bridge between its Riverside Drive address—a carriage entrance sits just off the corner—and its elegant yet slightly diminutive neighbors to the north on Claremont Avenue. The Paterno is paired with a similarly curved building, the Colosseum (built in 1910), across West 116th Street, creating a monumental entryway from Riverside Park and Riverside Drive to the gates of Columbia University.

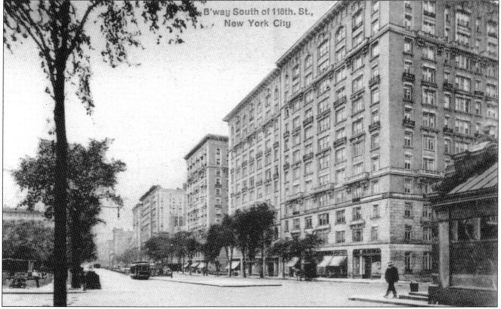

In 1913, the line of apartment houses on the west side of Broadway south from West 116th Street appears unbroken except for the spire of the Broadway Presbyterian Church, as it does today. Ollie's has been the longest-running establishment at this corner location since Chock Full o' Nuts closed in the 1980s.

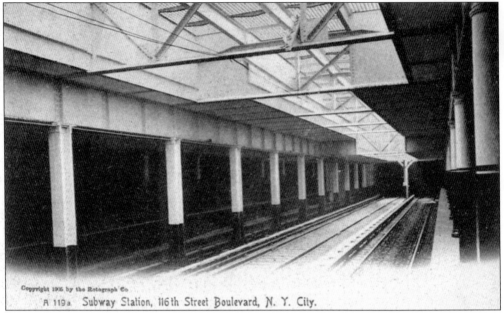

Copyright 1905 by the Rotograph Co

A 119a Subway Station, 116th Street Boulevard, N. Y. City.

Necessary to the growth of a middle-class neighborhood around the institutions of Morningside Heights was the extension of the first subway line to stations at 110th Street and 116th Street. The line came up from city hall and proceeded up Broadway to West 145th Street. In 1905, the new station at 116th Street was immortalized in this postcard image of a pristine, airy, and light-filled station.

563 THE SUBWAY CONCRETE ARCH AT 117TH STREET AND BROADWAY. NEW YORK.

William Barclay Parsons, a graduate of Columbia College in 1879 and the School of Mines in 1882, was the IRT's chief engineer at the time of the building of the first subway line. He made sure that the color scheme for the 116th Street station was dominated by blue and white, and that there would be plenty of terra-cotta replicas of the university seal to make his alma mater proud.

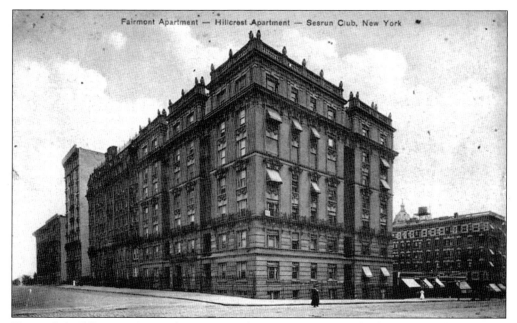

Two early buildings on Amsterdam Avenue, the Fairmont (center), built in 1901 at the southeast corner of Amsterdam Avenue and West 116th Street, and the Hillcrest (left), built in 1900, were designed by Neville and Bagge. The one-story commercial building on the right is now the location of the Columbia Law School and Business School's William and June Warren Hall (built in 1999 by the Hillier Group).

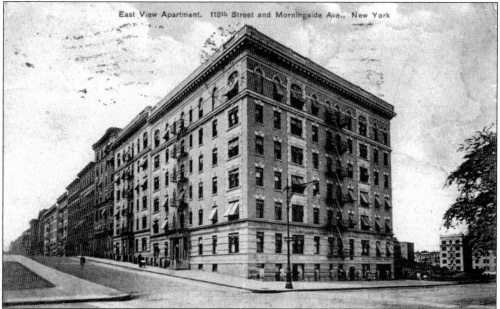

Typical of development along Morningside Drive is the six-story East View and, to its left along West 118th Street, the Terrace. Both were built in 1907 by the prolific architects Neville and Bagge. The plot of land behind the East View would become the residential hotel Butler Hall (built in 1924 by George F. Pelham). The land across West 118th Street is now the East Campus dormitory (built between 1977 and 1981 by Gwathmey Siegel and Associates).

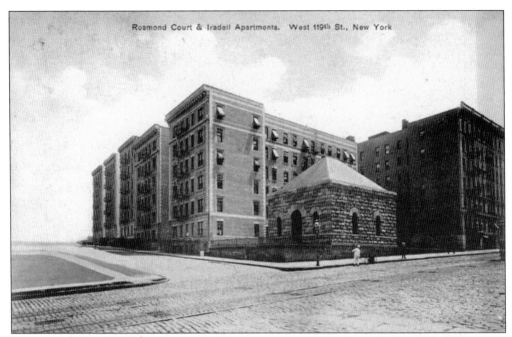

This view southeast across Amsterdam Avenue at West 119th Street has not changed much in a century. The Rosmond Court and Iradell were designed by Sommerfeld and Steckler in 1908 and 1909 using courtyards to enhance the entryways. The Croton Aqueduct gatehouse dates from the 1880s. The empty plot at left would soon be the site of Laureate Hall.

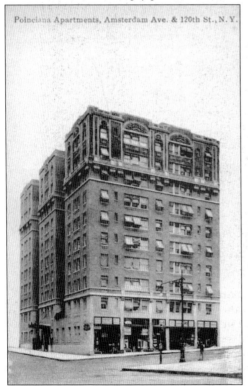

The Poinciana is one of the few exceptionally grand buildings to be erected to the east of campus. Built by Schwartz and Gross in 1912, it sits regally on the southeast corner of West 120th Street and Amsterdam Avenue, where it has been home for several generations to Hartley Chemists.

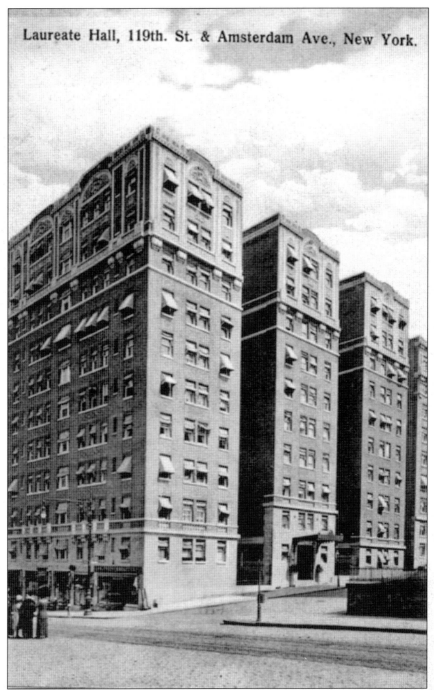

Laureate Hall, 119th. St. & Amsterdam Ave., New York.

Equally impressive is Laureate Hall directly to the south of the Poinciana at the corner of Amsterdam Avenue and West 119th Street. Built in 1911 by Schwartz and Gross, it is almost a perfect mirror image of the later Poinciana. It was advertised as the "last word in modern apartment house construction. Its fittings are perfect; its decoration will please the most critical. All the rooms are large and light and perfectly appointed." Opening day rents ranged from $1,690 per year for a two-room suite to $3,900 for a four-room suite.

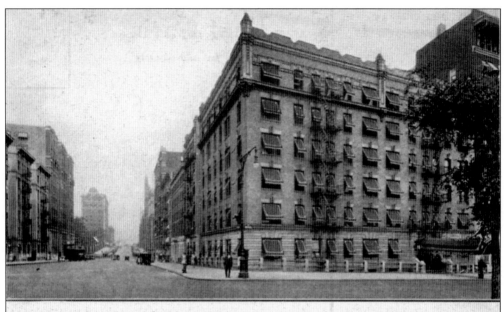

MAIN BUILDING OF THE MORNINGSIDE RESIDENCE CLUB 100 MORNINGSIDE DRIVE AT 120TH ST., NEW YORK CITY

The Palmetto at the northwest corner of Morningside Drive at West 120th Street was designed as a modest six-story apartment house in 1909 by George F. Pelham. In 1928, the Morningside Residence Club, which had been organized in 1919 as an alternative to the isolation and expense of hotel living, bought the Palmetto for $396,500.

The Morningside Residence Club was open to both single men and single women, although they would reside on separate floors, and housekeeping suites were available for married couples and families. The slogan of the club was "Normal Living." From its advertising, it appears that this involved ample opportunities for socializing, especially on the roof garden. Here there were Sunday afternoon teas and performances by the Morningside orchestra.

104

The reception room of the Morningside Residence Club contained a Steinway grand piano and a radio, while the parlor contained a Duo-Art player piano. In these rooms, French conversation classes as well as choral group practices were held; even a theater group and bridge club thrived.

Here is another view of the club's roof garden, this time looking south toward Butler Hall at West 119th Street. The club dues of $5 per year paid for all social events and roof garden expenses. Room and board was extra (starting at $6 per week), as were excursions around the town, theater parties, and Saturday evenings at the Metropolitan Opera (subscription tickets were priced at $1.25).

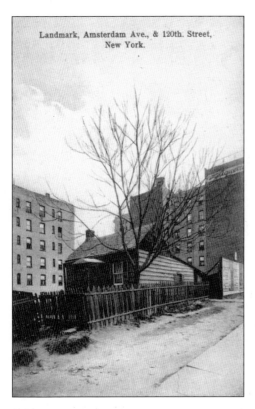

Landmark, Amsterdam Ave., & 120th. Street, New York.

Matilda the goat lived in this shanty on the northeast corner of Amsterdam Avenue and West 120th Street around 1910 with her owner Patrick Riley, who lent her out for hazing ceremonies among the undergraduates. When she died in 1914, students held a great funeral procession in cap and gown.

The Last Harlem Goat

Matilda was stuffed with sawdust and excelsior and placed in a niche above the door of Friedgen Pharmacy, across the street from the shanty in Whittier Hall. In 1954, after a full refurbishment, she was placed in the window of Friedgen's successor store, which closed in 1960. No one knows Matilda's whereabouts today, but she was immortalized in the 1956 children's book *Matilda* by Le Grand Henderson.

Seven

UPPER MORNINGSIDE HEIGHTS
WEST 120TH TO WEST 125TH STREETS

Heading north above West 120th Street, the plateau of Morningside Heights slopes down toward Manhattanville, and the IRT subway emerges onto an elevated track. With access to the station high above Manhattan Street (now 125th Street), this became a neighborhood of middle-class apartment dwellers. To the west, however, the heights culminate in a magnificent bluff overlooking the Hudson River. With sweeping views along the river, this was the site of the famed Claremont Inn, a gathering place for royalty and high society after 1860. Here in 1897, the area's most monumental structure, Grant's Tomb, was erected by popular subscription, forever challenging visitors with the conundrum of "who's buried in Grant's Tomb?"

Upper Morningside Heights became home to several other world-renowned institutions of higher learning and spirituality. Just north of Columbia, along West 120th Street, Teachers College occupied its first building in 1894, a year before Low Memorial Library's cornerstone was laid. Established by Columbia professor Nicholas Murray Butler in 1887 as the New York College for the Training of Teachers, the college operated the Model School, which became the Horace Mann School, which moved to the heights in 1901. The school eventually separated from Teachers College and moved to Riverdale in the Bronx.

Union Theological Seminary joined the procession uptown in 1905, when it purchased a sizeable plot of land to the north of Barnard College. Classes commenced here in 1910 in a Collegiate Gothic complex designed by Allen and Collens. The same firm designed the Riverside Church in the 1920s. The church and the nearby International House were sponsored by John D. Rockefeller Jr., and both projects necessitated the demolition of homes and relatively new apartment buildings along Riverside Drive.

Closer to Broadway, the Institute of Musical Arts, established in 1904, moved to a mansard roof structure on the heights in 1910 that was substantially remodeled and extended as it merged with the Julliard School of Music in 1926. Julliard eventually moved to Lincoln Center, and today this structure houses the Manhattan School of Music. On the east side of Broadway between West 122nd and West 123rd Streets, the Jewish Theological Seminary constructed a Colonial Revival–style complex beginning in 1929.

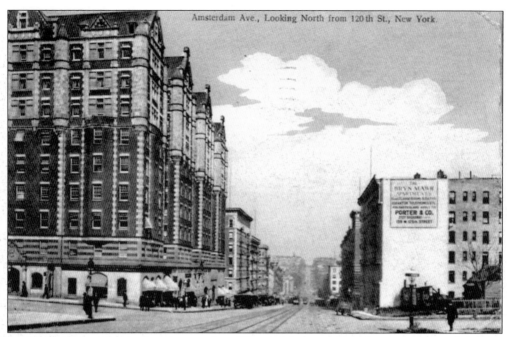

Looking north on Amsterdam Avenue from West 120th Street in 1910, one sees Patrick Riley's shanty on the northeast corner where the Edmund Francis would be built by George F. Pelham two years later. Across the street, Whittier Hall, erected in 1901 as a residence for women students and staff, was subsequently bought by the adjacent Teachers College in 1909.

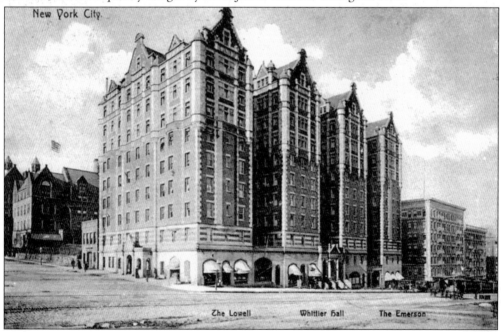

The imposing complex of Whittier Hall is actually comprised of, from left to right, Lowell, Longfellow, Whittier, and Emerson Halls. Due to its triple courtyard design by Bruce Price and J. M. A. Darragh, all rooms are outside ones. Kings College (built in 1905 by Neville and Bagge) sits on the corner directly to the north at West 121st Street.

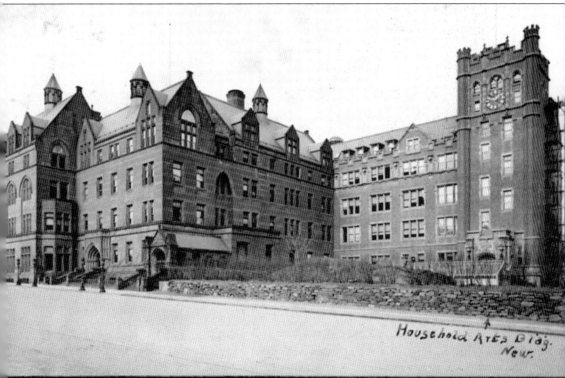

Finishing touches are being put on Teachers College's Household Arts Building (built by Parish and Schroeder) in 1909 overlooking the Green at the northern end of Columbia's campus. This view is mid-block on West 120th Street between Broadway and Amsterdam Avenue. The hall was the gift of Grace Hoadley Dodge, an early proponent of the domestic arts, for whom the building was renamed after her death. Russell Hall was built by Allen and Collens on the lot in front of Household Arts from 1922 to 1924, creating an internal courtyard. Main Hall (left), built in 1894 by William Potter, is the oldest building of the Teachers College complex.

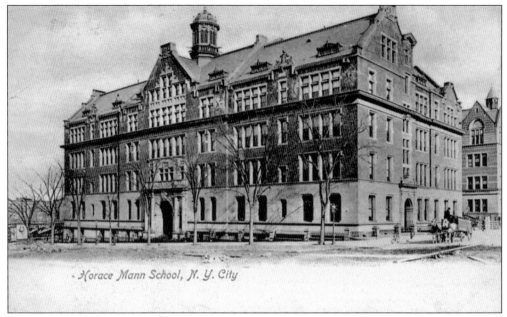

Horace Mann School, N. Y. City

The Horace Mann School was begun in 1887 as a school for educational experimentation and the demonstration of superior class teaching and school management at Teachers College. In 1901, this building was erected by the firm Howell and Stokes along with Edgar H. Josselyn on Broadway at West 120th Street and made possible by a gift of Mr. and Mrs. V. Everitt Macy as a memorial to their daughter Caroline Macy.

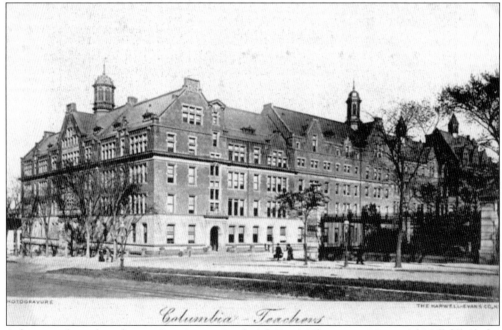

Columbia - Teachers

A few years later than the previous image, Frederick Ferris Thompson Memorial Hall fills in the empty lot between Horace Mann School and Milbank Memorial Hall (built in 1887). Completed in 1904 from a design by Parish and Schroeder, Thompson Memorial Hall contained gymnasium facilities, exercise rooms, handball courts, and a swimming pool.

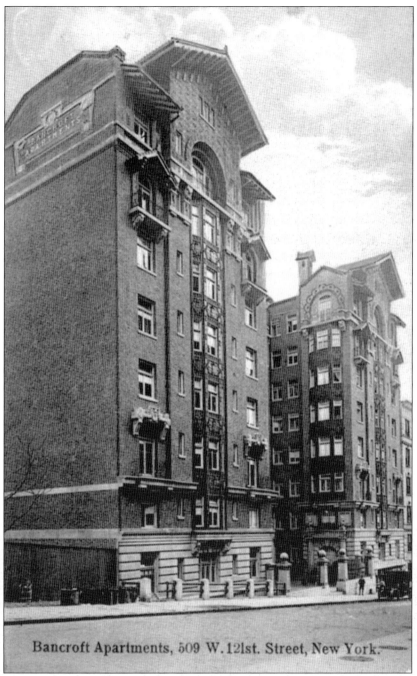

Bancroft Apartments, 509 W. 121st. Street, New York.

Teachers College acquired the Bancroft Apartments at 509 West 121st Street in 1919 to house its rapidly growing number of faculty and students, many with families. Designed by the prestigious architect Emery Roth and built in 1910, the building was originally advertised as the Sethlow Kitchenette or Sethlow Bachelor Apartments, to the consternation of Seth Low. Fearing legal proceedings, developers renamed the building. Fortuitously, leases for tenants living in the building at the time of purchase expired in September 1919 and Teachers College obtained the building empty, thus housing almost 400 students.

JANUS COURT, 100 Morningside Drive, N. Y. City.

Teachers College purchased Janus Court apartments (built in 1910 by John M. Baker) at the southwest corner of West 121st Street on Morningside Drive late in 1919. Here the existing leases ran longer than at the Bancroft Apartments and new housing laws were passed to help stave off eviction in such circumstances. In this case, it took Teachers College eight years to acquire many of the apartments. Janus Court was renamed Seth Low Hall at the time of purchase, three years after Low's death.

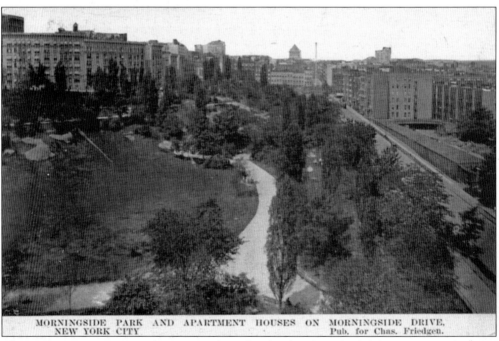

MORNINGSIDE PARK AND APARTMENT HOUSES ON MORNINGSIDE DRIVE, NEW YORK CITY
Pub. for Chas. Friedgen.

The northernmost portion of Morningside Park is bordered on the left by Morningside Drive as it curves toward its intersection with Amsterdam Avenue, and on the right by West 123rd Street. Grant's Tomb is in the distance.

The sweeping curve of Morningside Drive dictated the shape of the two buildings on the left in the lower image on page 112. This apartment house, the second from the left in that image, is known as the Circle and was built in 1908 from a design by George F. Pelham. To its left is another Pelham design, built a year later, named Shelburne Hall.

THE CIRCLE, 114 Morningside Drive, N. Y. City.

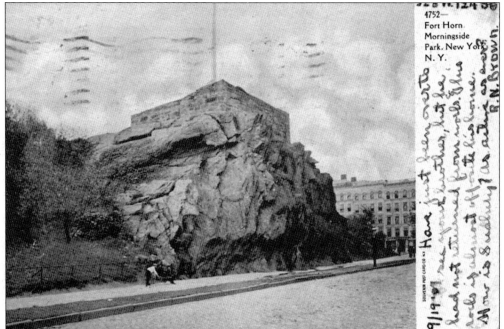

Blockhouse No. 4 in the northwest corner of Morningside Park at West 123rd Street, referred to here as Fort Horn, was a fortification built during the War of 1812. Public School 36, the Morningside School, was built on the site in 1967.

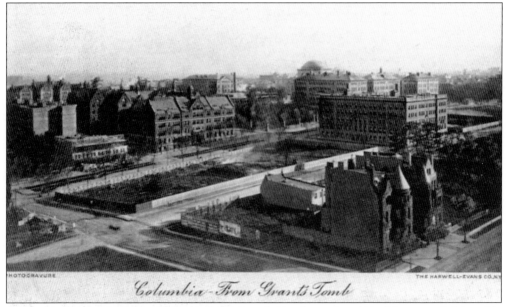

Columbia - From Grant's Tomb

This view from 1904 looks southeast from Grant's Tomb at West 122nd Street and Riverside Drive toward the campuses of Teachers College, Columbia University, and Barnard College. The empty lot in the center would soon give rise to Union Theological Seminary. And although further building would occur around the townhouses on Riverside Drive, this block would be developed in the late 1920s as the Riverside Church.

This is a 1910 view of the Reed House, which was built in 1905 by Neville and Bagge at the northeast corner of Broadway and West 121st Street. The building can be seen under construction in the image above. Corpus Christi Roman Catholic Church, to the right of Reed House on West 121st Street, was built in 1906. The present church edifice replaced it in 1935.

These two postcards depict substantial buildings with remarkably short existences. The apartment house in the postcard on the right was located at 490 Riverside Drive (built in 1909 by Neville and Bagge) just south of the two townhouses at West 122nd Street. Below is Dacona Hall, built in 1908 by Moor and Landsiedel at the southwest corner of West 122nd Street and Claremont Avenue. Both apartment buildings and the two townhouses, along with another apartment house on Claremont Avenue, were demolished in the late 1920s to early 1930s to accommodate the Riverside Church and expansion by Union Theological Seminary. (Collection of Bob Stonehill.)

490 RIVERSIDE DRIVE, NEW YORK CITY.
Pub. for Chas. Friedgen.

Approaching Union Theological Seminary from the south along Broadway around 1920, one sees the memorial entrance on the northwest corner of West 120th Street upon which the Brown Memorial Tower would rise in 1928. Farther along Broadway are the library and dormitory wings. These were all built from the designs of Allen and Collens from 1906 to 1910.

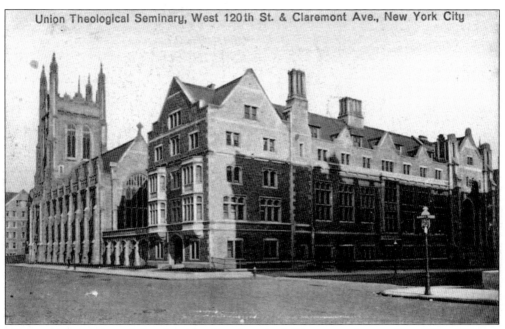

The seminary's campus is bordered by Broadway and Claremont Avenue from West 120th to West 122nd Streets. Continuing around this superblock to the northeast corner of Claremont Avenue and West 120th Street, from left to right, the James Chapel, President's House, and the administrative wing (built between 1906 and 1910) are visible.

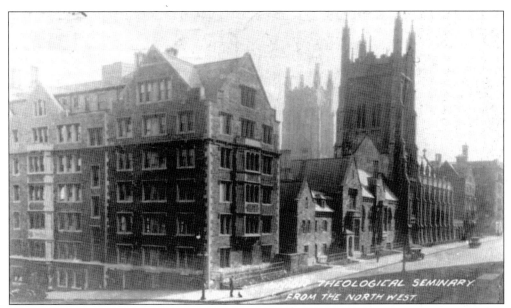

From Claremont Avenue and West 122nd Street on the north of Union's campus is Allen and Collens' faculty housing wing, part of the first phase of construction. A second phase of construction from 1925 through 1928 created a social hall, refectory, and the Brown Memorial Tower (seen in the background). This *c.* 1940 view looks virtually the same as it does today.

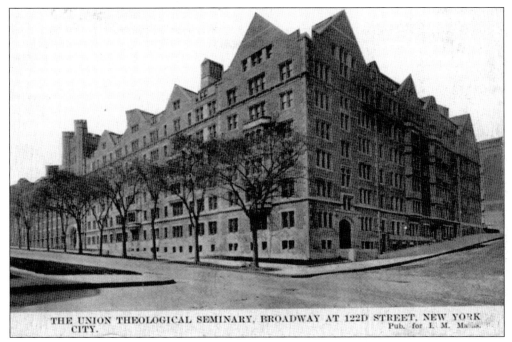

In this 1915 view, looking south from West 122nd Street along Broadway is the dormitory wing and the James Tower of Union Theological Seminary. A low fence is visible today; otherwise the view is virtually unchanged. Dacona Hall still stands to the right of the faculty residences up West 122nd Street across Claremont Avenue.

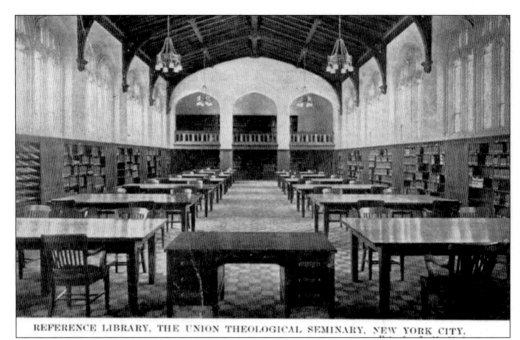

REFERENCE LIBRARY, THE UNION THEOLOGICAL SEMINARY, NEW YORK CITY.

The reference library of Union Theological Seminary was ready for classes to begin in 1910 and has seen generations of students in its almost 100 years on Morningside Heights. Today this space is the main reading room of the Burke Library, the largest theological library in the western hemisphere.

The Medina and Sonoma are two six-story apartment houses by Denby and Nute erected in 1905, their only buildings on Morningside Heights. The buildings are located at 189 and 191 Claremont Avenue between LaSalle Street (West 125th Street until 1920) and Tiemann Place (West 127th Street until 1921).

This Thaddeus Wilkerson view looks uptown along Broadway from West 122nd Street in 1909. Today the subway still rises to the viaduct for the 125th Street (then Manhattan Street) station, but the buildings at left were demolished for the expansion of the Institute of Musical Art, the lot at right is occupied by the Jewish Theological Seminary, and the buildings behind it were demolished for Morningside Gardens housing. (Collection of Bob Stonehill.)

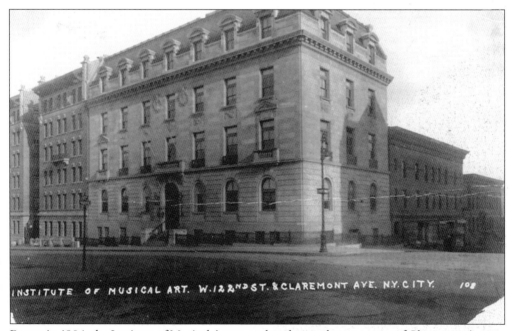

Begun in 1904, the Institute of Musical Art moved to the northwest corner of Claremont Avenue and West 122nd Street in 1910. Merging with the Julliard School in 1926, the institute renovated the building in 1931, removing the mansard roof. Since 1969 the building has been the home of the Manhattan School of Music. (Collection of Bob Stonehill.)

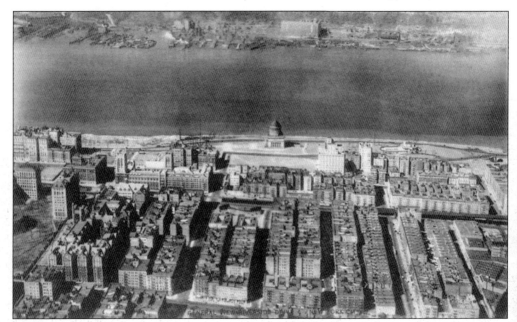

This *c.* 1928 aerial view looks west to the Hudson River over upper Morningside Heights from West 120th Street on the left to Tiemann Place on the right and shows the beginning of the steel frame construction of Riverside Church to the left of Grant's Tomb (center). All of the buildings in the lower right quadrant of the photograph were demolished for Morningside Gardens and the General Grant Houses in the mid-1950s.

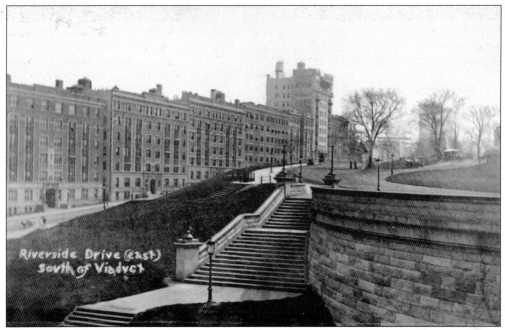

This view is looking south along Riverside Drive from West 127th Street (now Tiemann Place) in 1909. The Bordeaux, Montebello, Hague Dwelling, Claremont Court, Ulysses, Veronique, and Ardelle were all built from 1906 to 1908 on the hillside leading up to West 122nd Street. International House was built in 1922 on the site south of the last building shown.

A Thaddeus Wilkerson view taken from the top of an apartment building on Riverside Drive and present-day LaSalle Street shows West 125th Street from Broadway east across Harlem. The buildings in the left foreground were demolished for the General Grant Houses, those on the right for Morningside Gardens. West 125th Street today follows the diagonal off to the left from Morningside Avenue.

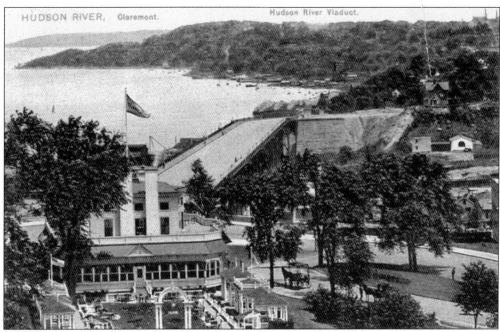

Claremont Hill, the site of the Battle of Harlem Heights in 1776, was also home to the Claremont Inn. This view looks north along the Riverside Drive viaduct (built in 1900) toward Manhattanville and along the Hudson River toward Washington Heights in the early years of the 20th century.

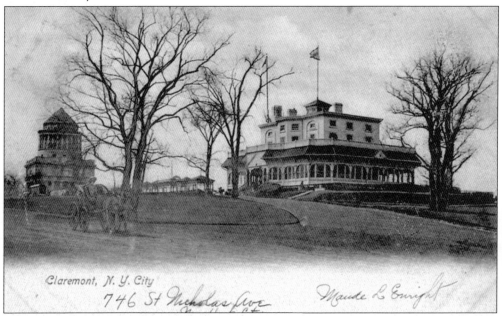

Believed to have been moved to this site from one closer to the river in 1804 by an Irish seafarer named Michael Hogan, Claremont, originally a home, survived well into the 20th century as the Claremont Inn, a gathering place for politicians, socialites, and entertainers, including the Vanderbilts, Whitneys, and Morgans. It was destroyed by fire in 1950 as it was being razed for a playground.

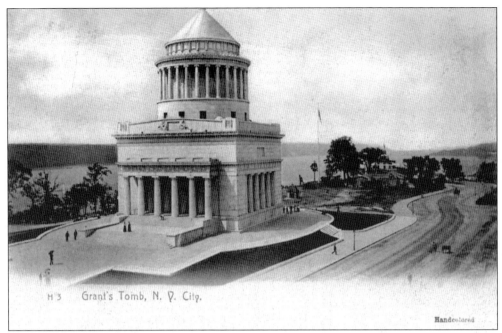

H 3 Grant's Tomb, N. Y. City.

Handcolored

Grant's Tomb has commanded this magnificent site to the south of the Claremont Inn since 1897. Gen. Ulysses S. Grant and his wife, Julia Dent Grant, lie in red porphyry sarcophagi within the vast interior. A national shrine, it was built from the design of John H. Duncan with donations from over 90,000 contributors amassing over $600,000.

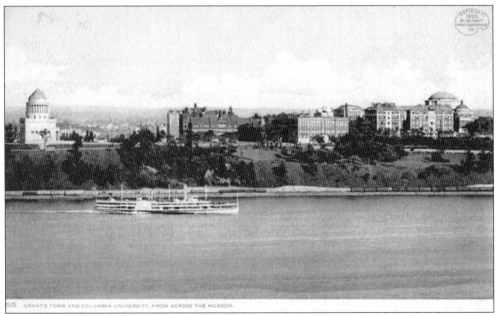

315. GRANT'S TOMB AND COLUMBIA UNIVERSITY, FROM ACROSS THE HUDSON.

Looking east over Morningside Heights on a beautiful sunny day in 1903, one can see from Grant's Tomb all the way down to Low Memorial Library. At that time, ferry excursions left from the recreation piers just north of Morningside Heights in Manhattanville.

This remembrance of a special late-spring day was written to the left of the photograph: "Riverside Drive – Near Grant's Tomb. Sat. May 12 [year unknown]. Miss Summers and I. Not good of either for we were any thing but sober. . . . Edith."

"Hurray! hurray! hurray GO-L-U-M-B-I-A!

This lovely, if somewhat melancholy, "college girl" has her heart in the right place trying to cheer on the team "Hurray! Hurray! Hurray C-O-L-U-M-B-I-A!" The fold-out portion of this banner card tucks in a slot by the "C" for ease of mailing.

This charming *c.* 1905 "college girl" postcard last changed hands when it was presented to a Princetonian from a Columbian 15 years ago. And though it may seem hard to believe given their vastly different undergraduate experiences, they are still going strong together!

BIBLIOGRAPHY

Bergdoll, Barry. *Mastering McKim's Plan: Columbia's First Century on Morningside Heights.* New York: Miriam and Ira Wallach Art Gallery, Columbia University, 1997.

Bogdan, Robert, and Todd Weseloh. *Real Photo Postcard Guide: The People's Photography.* Syracuse, NY: Syracuse University Press, 2006.

Dolkart, Andrew. *Morningside Heights: A History of its Architecture & Development.* New York: Columbia University Press, 1998.

King, Moses. *King's Handbook of New York City: An Outline History and Description of the American Metropolis, with over Eight Hundred Illustrations.* Boston: Moses King, 1892.

_____. *Notable New Yorkers of 1896–1899: A Companion Volume to King's Handbook of New York City.* New York and Boston: Moses King, 1899.

Robinson, Henry Morton. *Children of Morningside.* New York: O. S. Whitelock, 1924.

Robson, John William, ed. *A Guide to Columbia University: With Some Account of its History and Traditions.* New York: Columbia University Press, 1937.

Wickersham, George W. *The Cathedral Church of St. John the Divine.* [New York]: C. Harrison Conroy Company, Inc., 1989.

Across America, People are Discovering Something Wonderful. *Their Heritage.*

Arcadia Publishing is the leading local history publisher in the United States. With more than 3,000 titles in print and hundreds of new titles released every year, Arcadia has extensive specialized experience chronicling the history of communities and celebrating America's hidden stories, bringing to life the people, places, and events from the past. To discover the history of other communities across the nation, please visit:

www.arcadiapublishing.com

Customized search tools allow you to find regional history books about the town where you grew up, the cities where your friends and family live, the town where your parents met, or even that retirement spot you've been dreaming about.